LONDON
TRACTION

Hugh Llewelyn

AMBERLEY

First published 2018

Amberley Publishing
The Hill, Stroud
Gloucestershire, GL5 4EP

www.amberley-books.com

Copyright © Hugh Llewelyn, 2018

The right of Hugh Llewelyn to be identified as
the Author of this work has been asserted in
accordance with the Copyrights, Designs and
Patents Act 1988.

ISBN 978 1 4456 7797 2 (print)
ISBN 978 1 4456 7798 9 (ebook)

British Library Cataloguing in Publication Data.
A catalogue record for this book is available from
the British Library.

Origination by Amberley Publishing.
Printed in the UK.

Contents

Introduction

This book is not a comprehensive record of modern traction in the London area; rather, it is simply a selection of photographs that I have taken from the early 1960s to the present day, during which time I have lived in, worked in, commuted to and visited London and its environs. I have taken a very liberal view of what constitutes the metropolis and have chosen the M25 as my guide – although some photographs were taken outside that boundary.

My photographs date from my early teenage years to my retirement but when I took them I never gave a thought to them being included in a book. They are therefore no more than a personal record of traction as circumstances allowed. There were periods when I was not working in London and rarely visited because of family and career commitments, so there are large gaps in the timeline of my photographs. Moreover, the locations reflect my favourite stations or ones which were convenient to visit at a particular time. Having been brought up in South Wales, inevitably Paddington and stations on the former Great Western lines were and are a firm favourite. But running close is King's Cross. Although not as large or as spectacular as Paddington, King's Cross is such an architecturally well-balanced building that, aesthetically, I find it the most attractive London terminus. Moreover, as my first visits were in the days of steam, I could not but fail to be impressed by the ex-LNER 4-6-2s and 2-6-2s that simmered beneath its roof – so much larger locomotives than any of the GWR 4-6-0s I was used to. And then when the diesel invasion began, while the uniquely styled Westerns remain my favourite diesel locomotives, the Deltics were nonetheless a huge attraction – the most powerful diesel locomotives in the world at the time. Hence Paddington and King's Cross are probably over-represented in this book!

When living in South Wales, my interest in EMUs was mild: how could they compare to Westerns and Hymeks! However, after graduating I first moved to Sussex and then various northern and south-western suburbs of London, which led to me commuting on SR, LMR and ER EMUs into Victoria, Waterloo, Euston and Liverpool Street. This resulted in the growth of my interest in not just those termini, but also the traction that got me there.

The era of HSTs and the electrified WCML and ECML added to the great variety of traction to photograph and again, some classes I find more interesting than others, most notably the Class 43s and Class 90s. These therefore tend to feature more in this book than others.

Despite the personal bias of this book, I believe that the changing nature of both the traction and the locations over the decades is evident and that this will all add to your enjoyment.

I must explain why I have arranged and entitled the chapters after the pre-Grouping companies, which disappeared in 1923. At first sight this seems very incongruous. However, arranging the chapters after the regions of British Railways would have resulted in possibly too large divisions. On the other hand, with privatisation resulting in many franchises being changed over the years, it would have been impractical to use them as a guide – particularly as the whole BR era would not have fitted in such an arrangement. So adopting the pre-Grouping companies for chapters was the only practical choice left. And, as I compiled the book, I found that it worked!

Chapter 1

Great Western Lines

It was originally intended that the Great Western Railway would share the London & Southampton Railway's tracks into Nine Elms, superseded by an intention to share the London & Birmingham Railway's route into Euston. But no agreements could be made. Instead, the GWR built its own terminus at Paddington, opened in 1838 and then replaced by the present station in 1854, subsequently extended and modernised several times. Brunel's masterpiece has provided a fitting backdrop to the trains that have graced its platforms over the years. The four trainsheds, while not as individually spectacular as Barlow's single huge trainshed at St Pancras, nonetheless form an impressive scene. From being the only London termini where the diesel-hydraulics could be seen (apart from a brief period in Waterloo), it is now, and has been for more than four decades, the best place to see HSTs. But even those days are now rapidly disappearing with the introduction of the Hitachi EMUs in ever-increasing numbers. For such a major station, the Paddington suburban services to the west have, until very recently, had to make do with DMUs, although it has to be said that the suburban network was quite modest compared to those of other London termini, especially those south of the Thames.

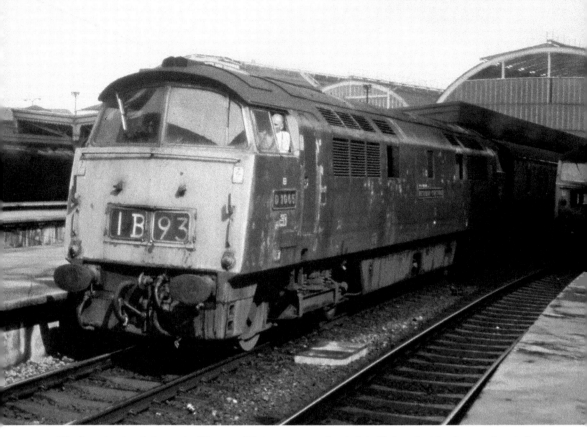

My favourite diesel class is the Westerns. Their imposing cabs, slightly V-shaped with a lip over the windscreens, and the side fairings covering the under-body equipment, give them an imposing presence that few other classes can match, in my opinion. Moreover, they are arguably the last gasp of the Great Western – or 'Great Western Region' as its successor was nicknamed in British Railways days! Inheriting the GWR's individuality, the Western Region's choice of hydraulic transmission rather than the BR standard of electric transmission separated the WR from other regions. The choice of the 'Western' prefix for the names of the WR's flagship class emphasised that distinctiveness. It is interesting that the two Maybach engines of the Westerns were capable of producing 3,000 hp but in the event they were limited to 2,700 hp. It is significant that, because of the very high tractive effort the Westerns produced, when they were being withdrawn by BR as 'non-standard', Foster Yeoman wanted to buy several to work their Mendip Quarry stone trains, but privatised locomotives running on a nationalised railway was too radical a concept to be acceptable at that time! Such an innovation had to await the arrival of the General Motors Class 59s twenty years later.

Pictured above is what BR classified as a Type 4 C-C and which under TOPS was categorised Class 52 – No. (D)1065 *Western Consort*. After the end of steam in 1968, the letter 'D' in front of diesel numbers was obsolete and painted out in the decals applied to most classes. However, the WR had dignified the Westerns with metal numberplates so, although the 'D' had been painted over on the 'Westerns' as in this picture, the letter was still clearly evident! Unfortunately, what was also evident in the '70s as the hydraulic classes were being withdrawn was their unkempt appearance, exacerbated by the fact that the Rail Blue (or Monastral Blue) livery of British Rail was far less hard-wearing than British Railways (Brunswick) Green. *Western Consort* is particularly shabby as it prepares to leave Paddington in July 1975.

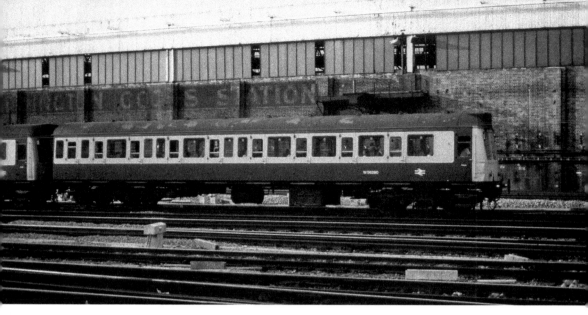

Seen passing Paddington Goods Station is Pressed Steel Class 149 Driving Trailer No. L231 (also numbered W56280) and – with only the cab visible – Class 121 railcar No. L131 (or No. W55031). No. L231 is in Rail Blue & Grey with all-yellow front ends and is heading towards Brunel's terminus on a service from Greenford in September 1982. The unpowered, single-cabbed Class 149s were designed to work with double-cabbed Class 121 and 122 railcars and added to the flexibility of the WR's DMU formations. BR's DMUs were initially painted green and in the 1960s were repainted into plain Rail Blue livery. However, eventually someone in BR must have considered this livery rather drab and in the 1980s DMUs were repainted into the much more attractive Inter-City livery of blue and light grey.

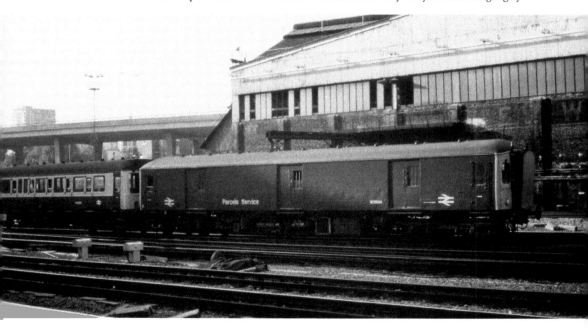

The Motor Parcels Van is a type of traction that has now disappeared. Here we see the variety built by Gloucester RC&W Co. Passing Paddington Goods Station in September 1982 is TOPS Class 128 No. W55991. The MPV was built with split headcode panels and central gangways so it could be coupled to other MPVs, Class 130 parcels conversions of DMU cars and even GUV parcels vans. However, by the time this photograph was taken, No. W55991 has had the headcode panels removed and replaced by marker lights, although the gangways remain; later the gangways were removed.

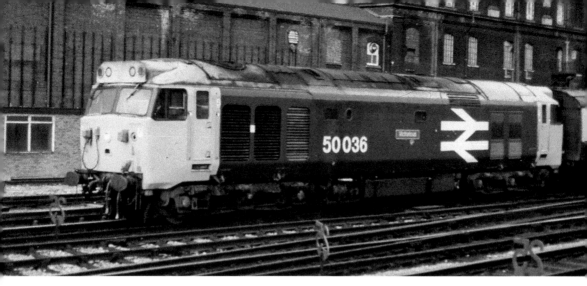

The English Electric Type 4 (TOPS Class 50) 2,700 hp Co-Cos were built in the late 1960s for that section of the West Coast Main Line which was not at that time electrified. However, once the Crewe–Glasgow section was electrified, the Class 50s were transferred to the Western Region in the mid-1970s. They replaced the last diesel-hydraulics on the WR and, although the loss of the Westerns was much lamented by railway enthusiasts, there was some consolation in that the WR named them after the diesel-hydraulic Warship classes. With no other regions having the Class 50s and with such 'heritage' names, the (G)WR spirit of individuality carried on for just a little longer! Seen here is No. 50036 (originally No. D436) *Victorious* in 'Large Logo Blue' livery and wrap-around yellow front ends as it nears Paddington with an express from Bristol (Temple Meads) in August 1984. When the 'Large Logo' livery first appeared in the early 1980s, I found it somewhat over the top, but it did bring some respite to the unrelieved blue hitherto dominant and in retrospect I find it rather pleasing.

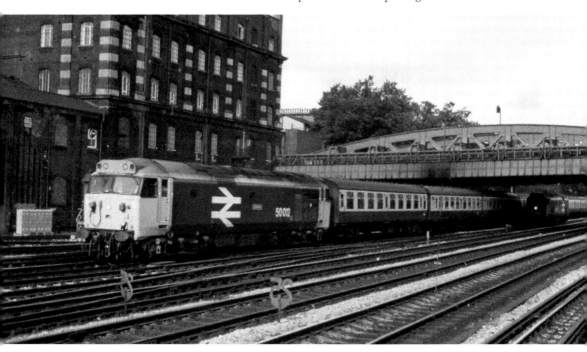

Approaching Paddington with an express from Bristol (Temple Meads) is English Electric Class 50 No. 50012 (ex-No. D412) *Benbow* in 'Large Logo Blue' livery, August 1984. Another Class 50 travels light engine on the adjacent track.

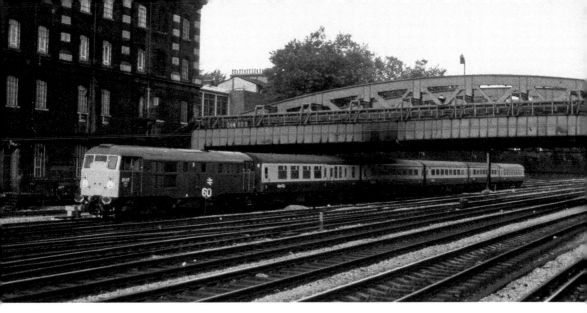

BR's requirement for its earlier diesel classes to have gangways – which in practice were very rarely used – often ruined the aesthetics of those classes, especially the smaller Type 2s. But I thought the Brush Type 2 (TOPS Class 30 and 31) A1A-A1As made the best of what could only be a bad job. For me, the front end of these locos achieved the heights of not being unattractive! The earlier builds benefitted even more from not having the top-heavy look of headcode boxes mounted on top of the cab. Class 31/1 No. 31117 (ex-No. D5535) seen here is an example. It is nearing Paddington with an empty stock working in August 1984.

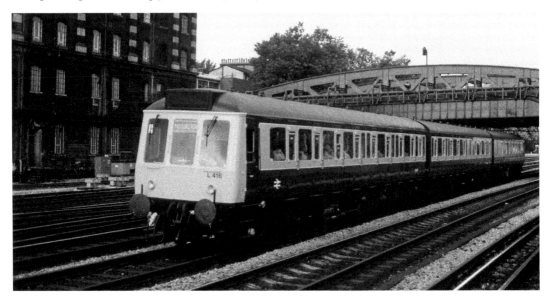

The standard suburban DMU design of BR Derby's works was the three-car Class 116 with mechanical transmission. However, the scale of the DMU orders BR wanted to make in the late 1950s and early 1960s meant that Derby simply did not have the capacity to produce the numbers BR required. As a result, the Birmingham Railway Carriage & Wagon Co., the Gloucester Railway Carriage & Wagon Co. and Pressed Steel were contracted to build the same design, although classified differently. These companies' sets were built in one, three and four-car formations and sometimes with different engines and transmissions from the Class 116. In this photograph Pressed Steel Class 117 three-car Suburban DMU No. L416, consisting of Class 117/1, 176 and 117/2 cars in Rail Blue & Grey livery, nears Paddington on a service from Reading in August 1984. Note that headcodes were no longer displayed by this time as No. L416's panel is blank.

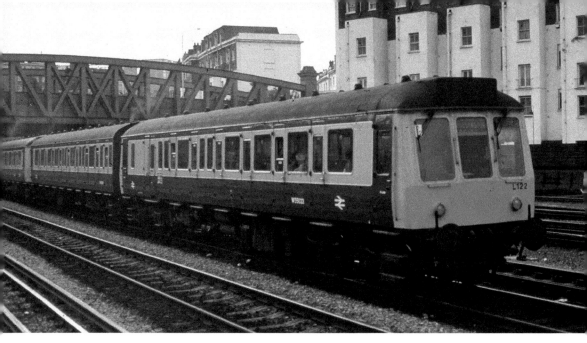

An interesting Pressed Steel DMU formation departs Paddington on a service to Henley-on-Thames, August 1984. At the rear is a two-car set made up of Class 121 railcar No. L122 (No. W55022) and Class 149 Driving Trailer No. L232 (No. W56283), coupled to an unidentified Class 117 three-car set (although only the cab is visible). Considering single railcars were intended for low-use branch lines, it seems a bit incongruous that the WR often used them to strengthen rush hour services in the capital! But they did have the benefit of flexibility so they could be added to other sets to provide the most appropriate formations for particular services.

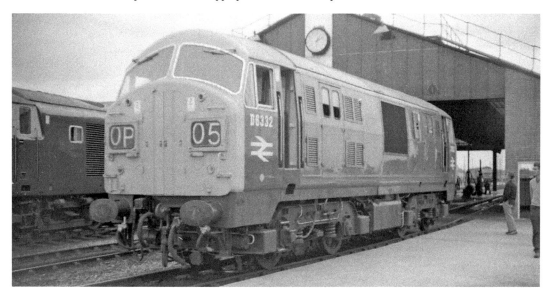

The huge and well-respected North British Locomotive Co. unfortunately never managed to carry forward its success in building steam locomotives to diesel ones. None of its designs for BR were highly regarded and all suffered from reliability problems to various degrees. The best that can be said of the hydraulic Type 2s built for the WR (later Class 22) is that they were not as chronically unreliable as the similar diesel-electric version (Class 21) used (when running) by the Scottish Region. And I think it is fair to say that they were not the prettiest of BR's diesels. Pictured is the 1,100 hp Class 22 B-B No. D6332 in Rail Blue livery, with divided headcodes and central gangways, at an open day at Old Oak Common TMD, July 1967.

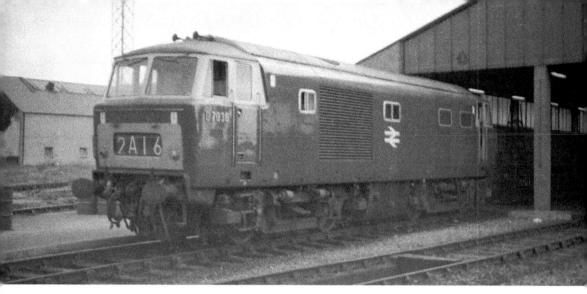

Present at the same Old Oak Common open day in July 1967 as No. D6332 is Beyer Peacock Type 3 (TOPS Class 35) Hymek 1,700 hp Bo-Bo No. (D)7036 in Rail Blue with small yellow warning panel. Although the 'D' prefix was not officially abolished by BR until the autumn of 1968, No. D7036 seems to have had its aluminium 'D' painted over. I have also seen a photograph dated June 1967 of a Western with its 'D' painted over. It may be that, because the WR got rid of its steam locomotive stock in 1965, they might have painted over its 'D' prefix earlier than other regions. The Hymeks were probably the most successful of the WR's diesel-hydraulics and were certainly the most reliable. The Maybach engine was rated to 1,900 hp in Germany but BR decided to derate them to 1,700 hp. Bearing in mind the compact size of the Hymeks, it would have been interesting to see how they would have performed if their engines had been rated at their full potential. Aesthetically, the Hymeks represented a welcome change from the many bland, even ugly, designs BR had previously procured. The body was designed by Wilkes & Ashmore and their two-window windscreen (the first on BR) and their sloped nose were a precursor of future designs such as the Classes 47, 50, 53 and 56. On the other hand, the raked-forward side-window recess was not perpetuated.

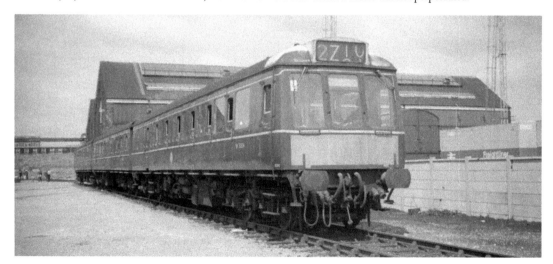

Another photograph taken at the July 1967 Old Oak Common Open Day; Pressed Steel Class 117 three-car suburban DMU Nos W51334 (Class 117/2), W59486 (Class 176) and W51376 (Class 117/1) is still in BR green with small yellow warning panels. The livery I liked best on the early DMUs was green but with the straw 'whiskers' instead of the later warning panel. Although the green used by the GWR and BR was supposed to be the same colour and usually referred to as Brunswick Green, it was never officially known as that; under the GWR it was Middle Chrome Green and under BR it was called Locomotive Green. However, in the period 1956–60 the green for DMUs was made lighter and known as Stock Green or Multiple Unit Green before reverting back to the darker shade.

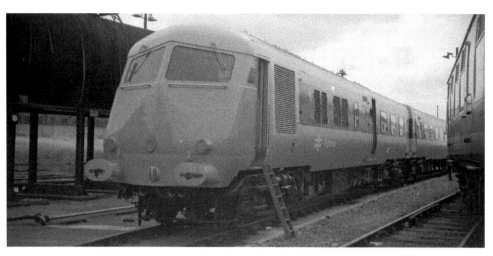

Precursor of the HST? The HST follows exactly the same concept as the Blue Pullmans – a semi-fixed formation of trailers with power cars at each end. The only substantial difference is that the Metropolitan Cammell-built Blue Pullmans were for a few elite services with supplementary fares whereas the HSTs were for everyone and deployed on standard express services. By the time this photograph was taken at the Old Oak Common Open Day in July 1967 the original livery of Nanking Blue with white window bands had been replaced by the corporate BR image of Rail Blue and Grey – but in reverse – with a Spectrum Yellow front end, the latter unfortunately obliterating the Pullman coat of arms previously carried on the front. In addition, the window band was extended further forward than in the original livery, while the frames and bogies were maroon instead of black. Apart from the rather over-indulgent yellow front end, I found this livery very attractive but presumably the preponderance of light grey made cleaning a bit of a headache. The Class 251 eight-car DMU was built for the WR's Bristol Pullman and South Wales Pullman services and shown is a set with Type 1 1,000 hp power car No. W60096 leading. With very luxurious accommodation for their time, the main fault of the cars was a poor ride and the onset of the HST rendered them obsolete. Consequently, all were withdrawn by mid-1974. Some cars were retained for possible preservation but, most unfortunately, none were preserved. It is interesting that classification of the HST prototype and production sets initially followed on from the Class 251 Blue Pullmans, that is, Classes 252, 253 and 254. Incidentally, the MR's six-car Blue Pullmans were Class 261.

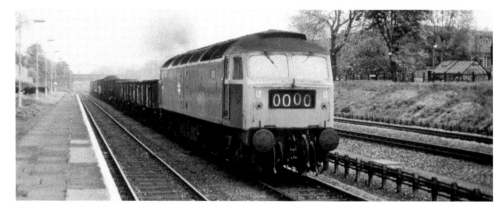

The Brush Type 4 (TOPS Class 47) 2,580 hp Co-Cos were BR's standard Type 4 but their original rating of 2,750 hp had to be lowered to 2,580 hp because of reliability problems with their engines. In doing so, their original sprightliness was lost. Nonetheless, they became one of BR's most successful designs and many examples are still in service today, albeit some re-engined with GM engines as Class 57. Pictured is Class 47/0 No. 47136 (originally No. D1728) rattling past West Ealing station pulling a mixed freight at a speed which looks rather testing for the short-wheelbase wagons being pulled. The Class 47's body was another Wilkes & Ashmore design.

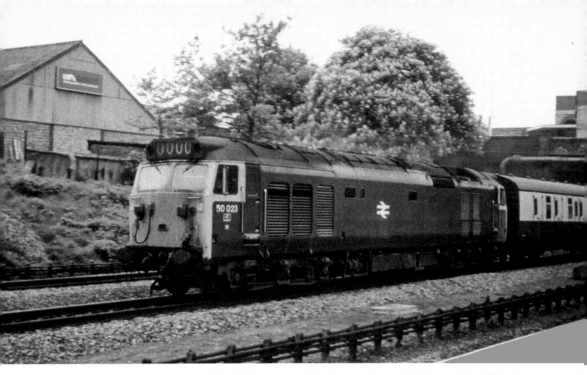

When I lived in London in the mid-1970s, West Ealing was one of my favourite haunts for photographing WR trains, with plenty of Class 52s, 50s, 47s and 31s to excite the senses! Here English Electric Class 50 No. 50023 (formerly No. D423), at that time unnamed but later named *Howe*, speeds past West Ealing station Paddington-bound, May 1976.

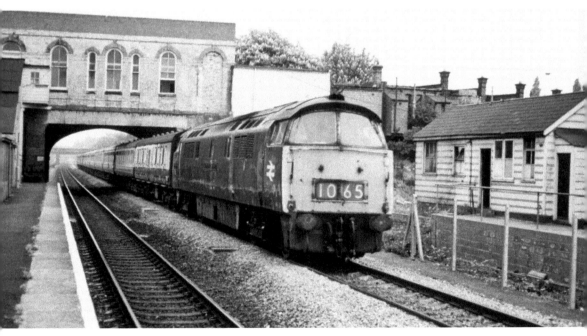

A shabby BR Class 52 2,700 hp Western diesel-hydraulic C-C, No. (D)1065 *Western Consort*, hurtles past Ealing on a Paddington–Swansea express, May 1976. The Westerns could not be fitted with the equipment necessary to work the latest ETH-equipped Mark 2D/E/F coaches and therefore by this time were restricted in what expresses they could haul, while the amount of freight services available was limited since there were plenty of Brush Class 47s for those. Coupled with BR's dislike of diesel-hydraulics, the Westerns were not destined for a long life.

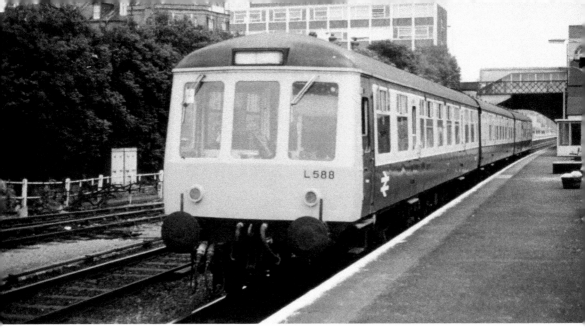

The standard BR Cross Country DMU was the Class 120 produced by Swindon, but the works did not have the capacity to meet the demand for such sets. As a consequence, the Gloucester RC&W Co. was contracted to build a batch. However, the company did not have all the tooling required to build copies of the Swindon design so, to avoid delay and additional costs in procuring all new tools, BR agreed that Gloucester could use some of the tooling they had already for manufacturing the Class 122 railcars based on Derby's standard suburban DMU. The Cross Country class that Gloucester produced was thus a hybrid of the Swindon and Derby designs. The Class 119 had a body similar to the Swindon Class 120 but with the standard Derby cab/front end, as in the Class 116/122. Seen at West Ealing on a Reading–Paddington service in May 1976 is Class 119 three-car set No. L588, made up of Class 119/1, 178 and 119/2 cars.

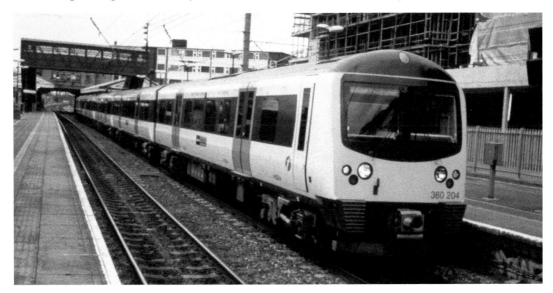

Siemens Class 360/2 Desiro 25 kV AC overhead five-car EMU No. 360204 of Heathrow Connect approaches Hayes & Harlington on a Paddington–Heathrow Airport service, April 2008. The Heathrow Connect service is a cheaper albeit slightly slower competitor to the Heathrow Express and, unlike the latter, is not non-stop. The Class 360/2s were built as Class 350 prototype vehicles and originally had gangways. The production version was South West Trains' Class 450. The Class 360/2s were then converted for use by Heathrow Connect and lost their cab gangways. Heathrow Connect will soon be replaced by Crossrail.

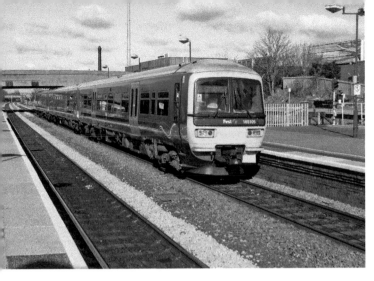

BREL (York) Class 165/1 Network Turbo three-car DMU No. 165105 of First Great Western speeds through Slough on a Reading–Paddington service, 24 March 2009. The set is in FGW's 'dynamic lines' livery, which is meant to convey, allegedly, dynamism.

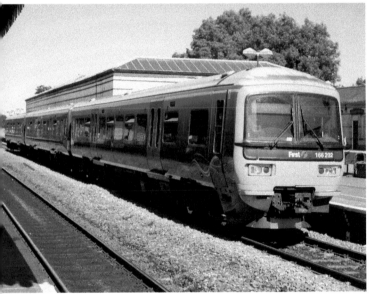

On privatisation, ABB bought BREL's York works, so further builds of the Network Turbo were ABB products. Here is Class 166 Network Express Turbo three-car DMU No. 166202 of First Great Western in 'dynamic lines' livery at Maidenhead on a Paddington–Oxford service, June 2009.

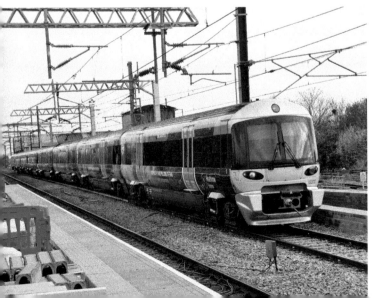

In my mind the Siemens 25 kV AC overhead Class 332 Heathrow Express design is one of the most attractive of modern EMUs. Speeding past Southall on the fast line on a Paddington–Heathrow Airport service on 16 November 2017 is four-car set No. 332012. The Class 332s have sported a variety of liveries over the years, most of them promotional, and No. 332012 is in Tata Communications livery.

On 16 November 2017, Bombardier Class 387/1 Electrostar express four-car MU No. 387136 of GWR in its smart retro Brunswick Green livery departs Southall and heads for Paddington.

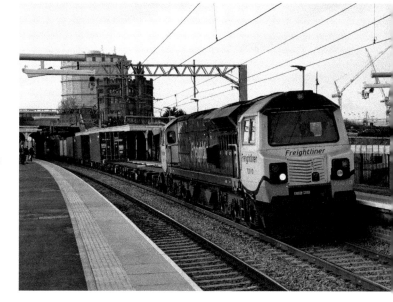

Possibly the ugliest of all diesels introduced after privatisation, General Electric Class 70/0 3,820 hp Co-Co No. 70010 trundles through Southall on the 09.25 4M58 Southampton–Garston Freightliner service on 16 November 2017. It was originally proposed to classify this design 69, which would have been more appropriate.

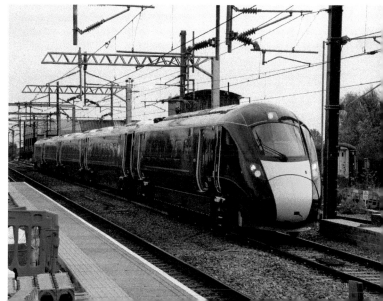

The new face of the GWML – Hitachi Class 800/0 25 kV AC overhead/diesel bi-mode five-car EMU No. 800014 of GWR in Brunswick Green livery speeds through Southall on a Paddington–Bristol Temple Meads service, 16 November 2017.

Chapter 2

Great Central Lines

The Great Central Railway was the last main line to reach London, in 1899, and its terminus at Marylebone, designed by Henry Braddock, is one of the smallest – but also one of the prettiest – of the major railway companies and was almost closed in the 1980s. Fortunately it survives and is now very well cared for by Chiltern Railways. Marylebone serves some of North London's more prosperous suburbs and, although the variety of traction there has always been more limited than at other termini, it currently is of interest in being one of the few to have diesel locomotive-hauled trains, leaving aside the debate on whether HSTs are loco-hauled or DMUs! What a contrast to the days of BR when all that could be seen at Marylebone were DMUs, although they did include the unique Class 115 DMUs, which were specially designed for the Marylebone suburban services with particularly powerful Albion engines.

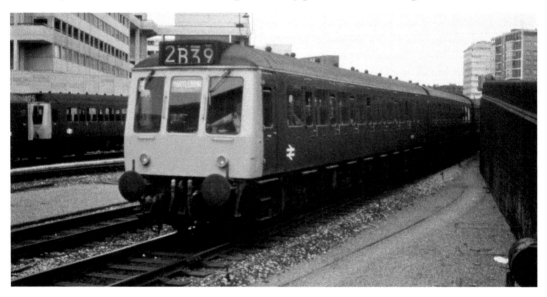

The Class 115 four-car sets intended for Marylebone services were a variation on the BR (Derby) standard suburban DMU design. They had more powerful Leyland Albion engines of 230 hp compared to the 150 hp BUT engines of most DMU designs. In addition, the accommodation was rather more luxurious than standard and they were often used on longer, outer suburban services. Seen arriving at Marylebone on a service from Aylesbury in July 1975 is a set composed of cars Nos M51889 (Class 115), M59738 (Class 173), M59672 (Class 177) and M51674 (Class 115) in the rather uninspiring plain Rail Blue livery. At this date the only trains operating out of Marylebone were Class 115 and 116 DMUs.

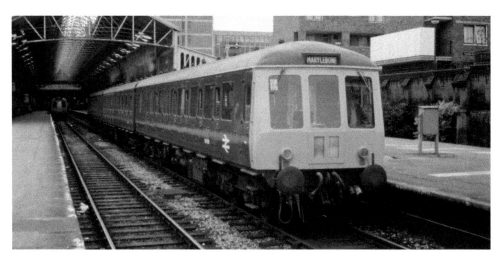

The standard BR suburban DMU was the Class 116 three-car DMU design built at Derby, on which many other similar designs were based. Their airy spaciousness, comfortable seats, cleanliness and good visibility – especially through the glazed partition behind the driver's cab – was a huge improvement over the loco-hauled stock they replaced. However, the vibration, noise and smell of diesel fumes caused by the under-floor engines, rattle-prone windows and a carriage heating system that always seemed to be on maximum heat was less palatable. These faults were common to almost all first generation DMUs although rectification programmes over the years helped to alleviate matters. The illustration is of a set made up of cars Nos M50861 (Class 116/2), M59351 (Class 175) and M50914 (Class 116/1) in Rail Blue leaving Marylebone on an ECS working, July 1975.

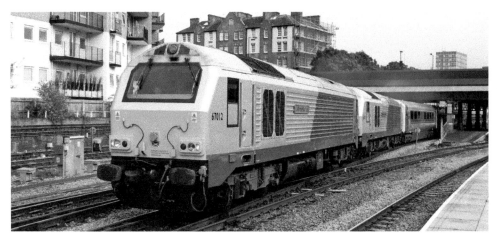

The Alstom Class 67 3,200 hp Bo-Bos were ordered by EWS specifically to haul high-speed Royal Mail trains but when EWS lost their contract just three years after their delivery, some very expensive assets lay idle. The locos have since found employment on passenger trains of various operators although usually quite light and not particularly fast. The locomotives have also been used on 'Thunderbird' duties and occasionally even on freights. Certainly, their full potential is rarely realised. Probably their greatest use has been on services out of Marylebone, initially with the much lauded but ultimately ill-fated Wrexham, Shropshire & Marylebone Railway on their Marylebone–North Wales services and subsequently with Chiltern Railways on their much more successful services to Birmingham. However, they have now been displaced from this service by the Class 68s. It was not very often that the Class 67s double-headed but here is such an occasion. No. 67012 *A Shropshire Lad* and No. 67013 *Dyfrbont Pontcysyllte* (I can pronounce it – can you?) of Chiltern Railways, in debranded Wrexham, Shropshire & Marylebone Railway silver livery, provide a gross excess of power for a Marylebone–Birmingham Snow Hill service, 30 August 2012.

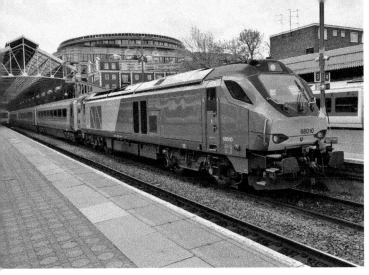

The new order at Marylebone: Vossloh Class 68 3,750 hp Bo-Bo No. 68010 of Chiltern Mainline in what had been debranded Wrexham, Shropshire & Marylebone grey and silver livery but was then adopted as the new Chiltern Mainline livery. The locomotive makes a fine sight at Marylebone on the 1R33 13.10 Birmingham (Moor St) service, 3 May 2016. The dramatic styling of the Class 68s seems to me a huge improvement over that of recent diesel designs for British operators.

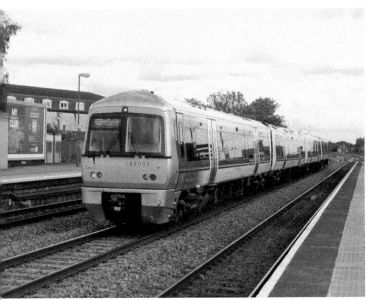

Adtranz Class 168/0 Clubman four-car DMU No. 168002 of Chiltern Railways Mainline in their latest livery speeds past South Ruislip on a Marylebone–Birmingham Snow Hill service, 12 May 2014.

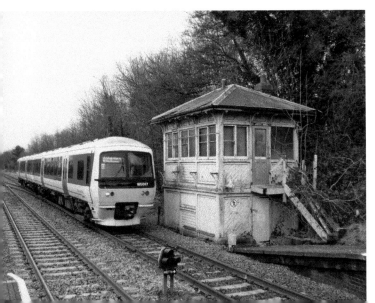

BREL (York) Class 165/0 Network Turbo two-car DMU No. 165017 of Chiltern Railways passes the disused ex-Great Central Railway signal box at Great Missenden on a Marylebone–Aylesbury service, 10 March 2008.

Chapter 3

North Western Lines

Euston was the one of the earliest main line termini in London (1837) and, at least in the early years, one of the more imposing. However, by the 1960s it was a mish-mash of buildings erected over the years and, understandably, was deemed by BR to be unfitted to the modern electric railway they planned for the WCML. As a result, old Euston was demolished but much good as well as bad was lost in the process. It was replaced in 1963–68 by the present modern station – soon to be replaced itself by a new one to serve HS2. Although the current station is disliked by many, I wonder if its loss will eventually be mourned as much as the original. I suspect it might well be as it is a fine example of 1960s architecture – like it or not! And I speak as someone who visited the old Euston once before it was turned into rubble. Euston has always had an interesting variety of traction serving it from the earliest main line diesels – the LMS Class 39s – to modern electric Class 390 Pendolinos.

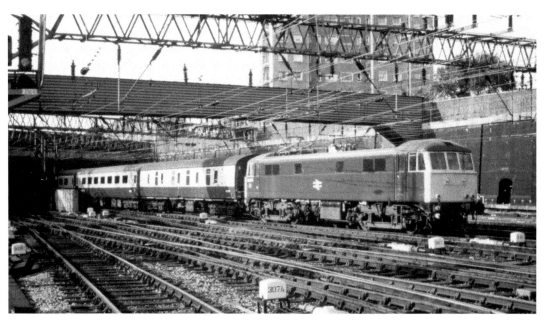

BR/English Electric Class 86/0 (previously Class AL6, later Class 86/2) 25 kV AC overhead 3,600 hp Bo-Bo No. 86030 (ex-No. E3105) entering Euston on a WCML express in September 1982. Unnamed at this time, the locomotive later became *St Edmund*, then *Scottish National Orchestra*. Introduced in 1965, it is quite amazing that some Class 86 locos are still in service, albeit now hauling freight rather than expresses.

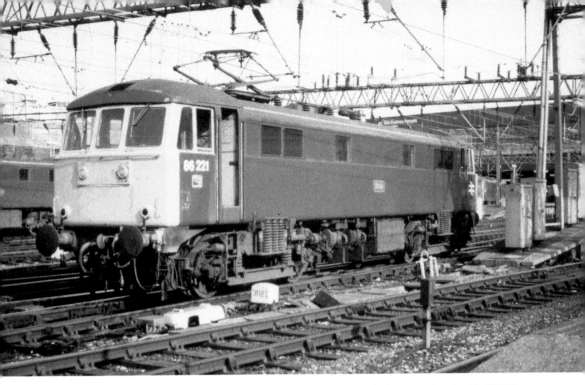

BR/English Electric Class 86/2 (previously Class 86/0 and originally Class AL6) No. 86221 *Vesta* (ex-No. E3132) at Euston, September 1982. By this date the headcode panels were plated up.

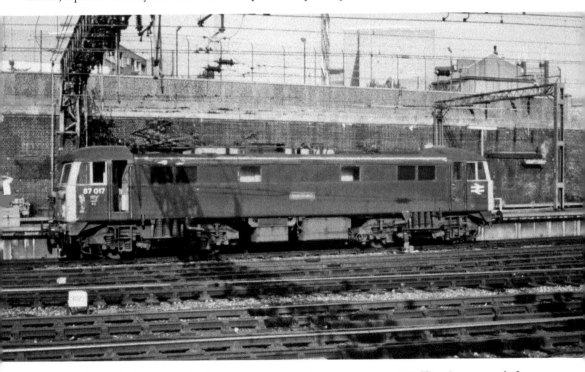

BREL/GEC Class 87 5,000 hp Bo-Bo No. 87017 *Iron Duke* at Euston, September 1982. This class appeared after TOPS was in operation but would have been classed as AL7 pre-TOPS. By the time the Class 87s were built in 1973–75 headcodes were no longer displayed and these locos were the first electric locomotives to be built without them.

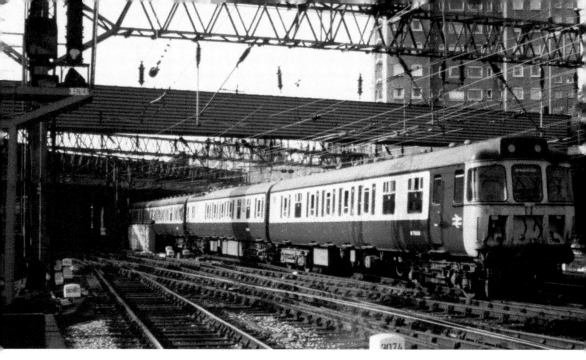

BR (LMR) Class 310 (originally Class AM10) 25 kV AC overhead four-car outer suburban EMU No. 310056 (ex-No. 056) in Rail Blue and Grey livery arriving at Euston on a service from Birmingham (New St), September 1982. The body shell of these units was based on the Mark 2 coach body and was of semi-integral construction. I commuted on the AM10s in the early 1970s and thought they compared very favourably to the Mark 1-based 4-VEPs on the SR, which were used on similar outer suburban/main line semi-fast services.

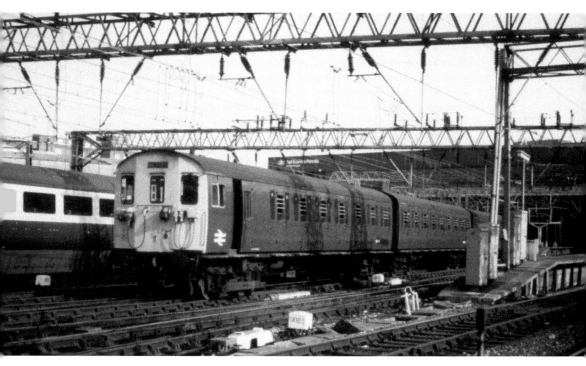

BR (LMR) 'London District' Class 501 750 V DC third rail (originally four-rail) inner suburban three-car EMU No. 501174 in Rail Blue draws into Euston on a service from Watford, September 1982.

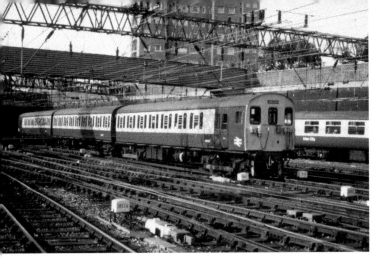

Another BR (LMR) 'London District' Class 501 unit, No. 501135, arrives at Euston on a service from Watford in September 1982, although this set is in Rail Blue and Grey livery.

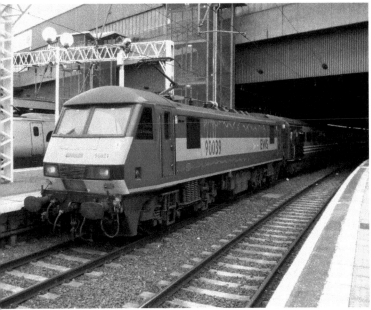

BREL/GEC Class 90 5,000 hp Bo-Bo No. 90039 (originally named *Crewe Basford Hall*) of EWS in their maroon livery at Euston on hire to Virgin West Coast on a Birmingham 'Pretendolino' service, 21 August 2007. This rake of loco-hauled Mk 3 coaches was formed due to a stock shortage resulting from the loss of a Pendolino set in the Grayrigg crash earlier that year.

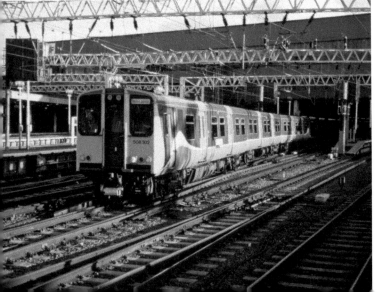

As the shadows of a short winter's day lengthen, BREL (York) Class 508/3 inner suburban 750 V DC third rail three-car EMU No. 508302 (ex-No. 508135) leaves Euston on a Watford Junction service, January 2008. The unit is in London Overground-branded Silverlink Metro livery.

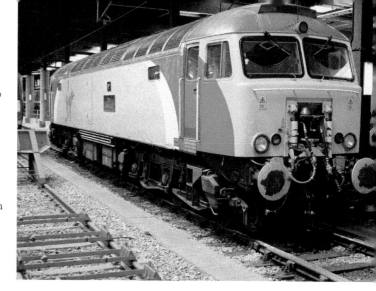

Brush Class 57/3 2,500 hp Co-Co No. 57305 *John Tracey* of Virgin on Thunderbird duty at Euston, 21 July 2008. Unusually, there were two Class 57 Thunderbirds at Euston that day. Normally, there was only one. No. 57305 was originally built as a Class 47 before re-engining and conversion to a Class 57. It was originally No. D1758 and was then renumbered 47164, 47751 and 47822. It had also been named *Pride of Shrewsbury*.

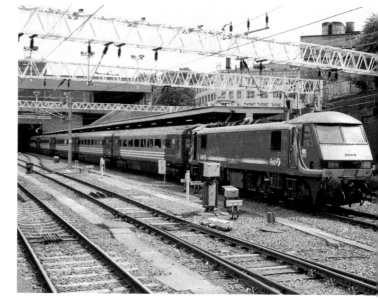

BREL/GEC Class 90 No. 90019 (previously named *Penny Black*) of DBS in EWS-branded Scotrail livery on hire to Virgin Trains; it is arriving at Euston on a 'Pretendolino' service from Birmingham New St, 12 June 2009.

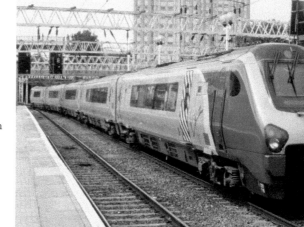

Bombardier Class 221 Super Voyager five-car DMU No. 221116 *David Livingstone* of Virgin West Coast leaving Euston on a Holyhead service, 12 June 2009. The Super Voyagers were a tilting version of the Class 220 Voyagers.

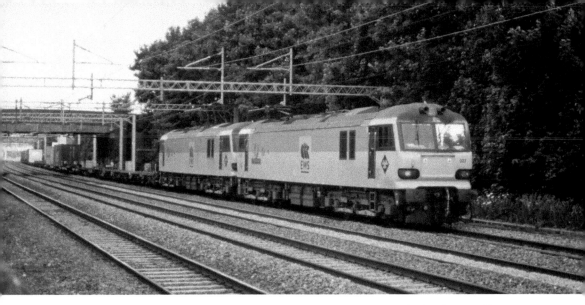

One of the impressive Brush Class 92 6,760 hp Co-Cos – the last electric locomotives built in Britain – No. 92022 *Charles Dickens* and an unidentified sister power past Headstone Lane on a Dollands Moor–Piacenza intermodal, June 2008. Both locomotives are in EWS-branded BR Trainload Freight two-tone grey livery. Note the Crewe Depot eagle plaque on the cab front. The Class 92s are very sophisticated machines and designed to work both on the 25 kV AC overhead and 750 V DC third rail systems. They were specifically designed for Channel Tunnel freight work and for hauling the proposed Nightstar sleeper service through the tunnel. Unfortunately the level of cross-channel freight fell far below expectations and the Nightstar never materialised. Consequently, they became rather underused assets despite many being used on internal UK freight and the Caledonian Sleeper, and some have therefore been sold to DB Cargo in Romania and Bulgaria.

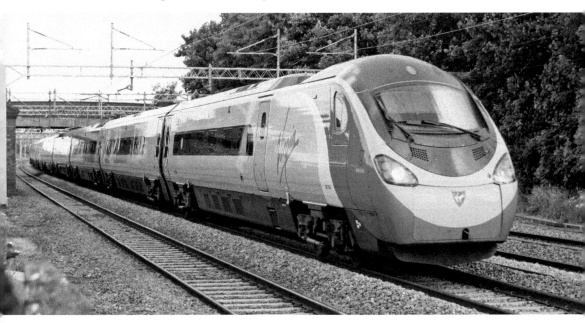

Alstom Class 390 Pendolino 25 kV AC high-speed express nine-car EMU No. 390014 *City of Manchester* of Virgin West Coast at Headstone Lane on a Glasgow Central–Euston service, 25 June 2008. Intended for 140 mph operation on an upgraded WCML, significant cost over-runs resulted in the project being downgraded to 125 mph. The Pendolinos have thus never reached their potential and the considerable investment by Virgin was somewhat wasted through no fault of their own.

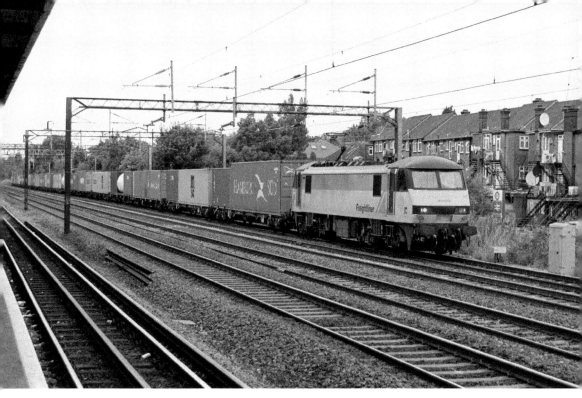

BREL/GEC Class 90 No. 90042 in Freightliner two-tone grey rumbling past Carpenders Park on a Coatbridge–Felixstowe container Freightliner service, 2 July 2008.

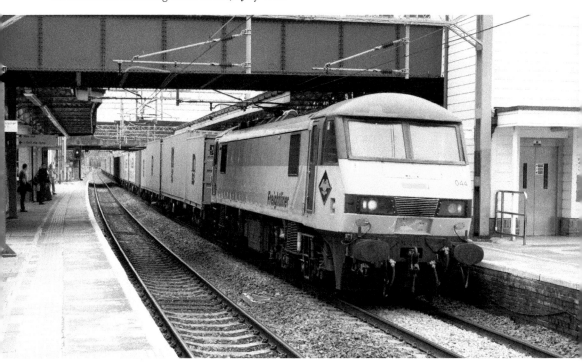

BREL/GEC Class 90 No. 90044 in Freightliner two-tone grey (and still with Crewe Depot eagle plaque) powering through Harrow & Wealdstone on a Felixstowe–Trafford Park container service, 2 July 2008.

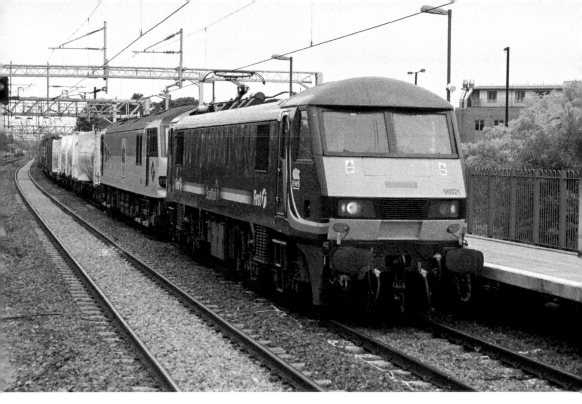

A double-headed Trafford Park–Wembley intermodal passes Harrow & Wealdstone on 2 July 2008 behind BREL/ GEC Class 90 No. 90021 of EWS/First Scotrail and an unidentified Class 92 of EWS.

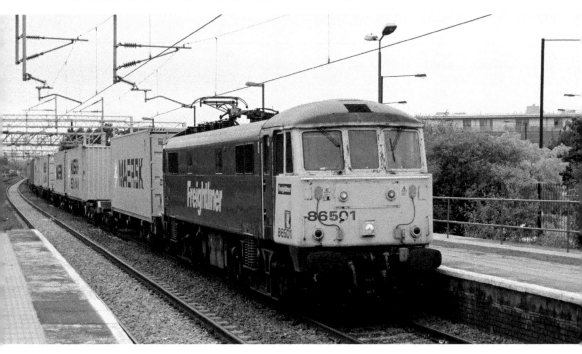

Unique BREL/English Electric Class 86/5 3,600 hp Bo-Bo No. 86501 (formerly Nos 86608, 86408, 86008 and E3180 and previously named *Crewe Basford Hall* and *St John Ambulance*) in Freightliner green livery at Harrow & Wealdstone on a Crewe Basford Hall–Felixstowe container service, 2 July 2008.

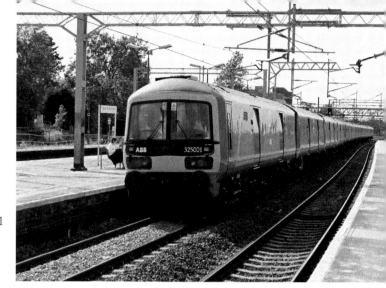

Again seen at Harrow & Wealdstone is ABB Royal Mail 25 kV AC overhead four-car postal EMU No. 325001 on a Willesden Railnet–Shieldmuir mail service, 25 June 2008.

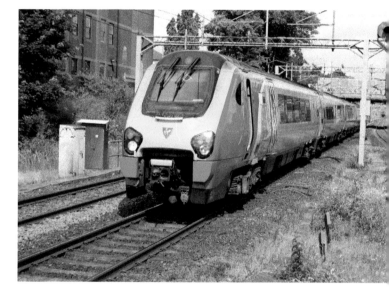

Bombardier Class 221 Super Voyager five-car DMU No. 221104 *Sir John Franklin* of Virgin West Coast arriving at Watford Junction on a Llandudno–Euston service, 25 June 2008.

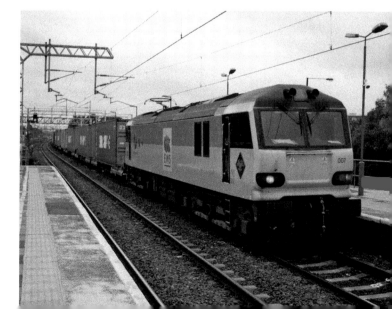

Pictured at Watford Junction is Brush Class 92 Co-Co No. 92007 *Schubert* of DBS in EWS-branded BR Trainload Freight two-tone grey livery on an Intermodal, 15 September 2009.

Chapter 4

Midland Lines

The Midland Railway were late building their own line to London, not finally reaching their goal until 1868. But when they got there, what an edifice they built in St Pancras. With what was then the largest single-arched trainshed in the world, designed by W. H. Barlow, St Pancras was undeniably impressive. Saved from demolition in the 1960s by a campaign spearheaded by Sir John Betjeman, the station nonetheless seemed to lead a moribund existence with even the electrified services from Bedford diverted to Moorgate. However, the coming of Eurostar and the insistence by the Secretary of State for the Environment, Michael Heseltine, that HS1 should help the regeneration of East London led to the originally planned route being diverted through Stratford to St Pancras. As a result, St Pancras was completely restored in 2001–7 and greatly extended with longer platforms and, unfortunately for the views of Barlow's trainshed, a large flat roof erected in front of it. As a result, while the interior of Barlow's trainshed is beautifully restored, photography of the East Midlands trains stuck underneath the flat roof is limited. What a contrast to the days of 'classic traction' when St Pancras was the main London haunt of the impressively long Peaks and the unique Class 127 DMUs, which were specially designed for the Midland suburban services with powerful Rolls-Royce engines and hydraulic transmission. Clearly, they were the Rolls-Royce of BR suburban DMUs.

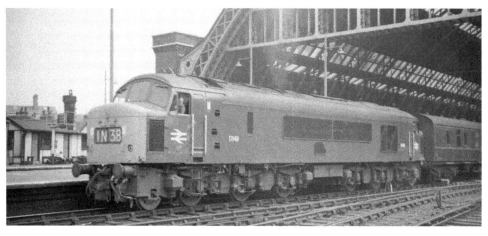

Under Barlow's spectacular trainshed at St Pancras, BR Type 4 (later TOPS Class 46) 2,500 hp 1Co-Co1 No. D149 (later No. 46012), with central headcode panels and in Rail Blue livery, creeps out of the station on a Leeds express in July 1967.

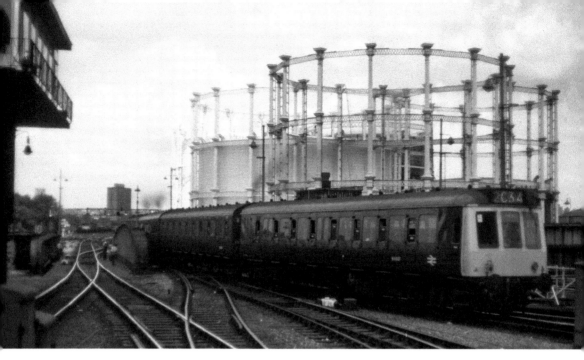

Forming a background are the huge, iconic gasometers – almost as impressive as Barlow's trainshed, some might say! In the foreground is what may be regarded as the Rolls-Royce of first generation DMUs – a BR (Derby) Class 127 four-car Suburban DMU with 238 hp Rolls-Royce engines. The set consists of cars Nos M51637 (Class 127), M59597 (Class 186), M59621 (Class 186) and M51605 (Class 127) in overall Rail Blue livery, which for me is certainly not the Rolls-Royce of railway liveries! The set is leaving St Pancras on a St Albans service in September 1975.

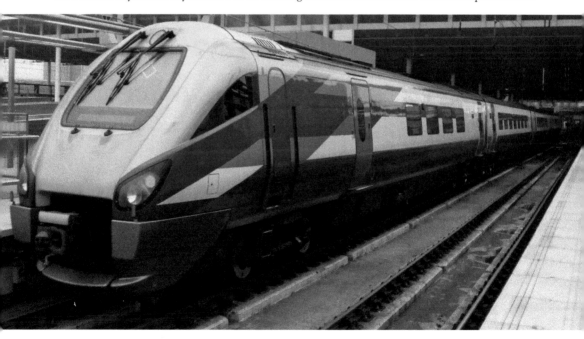

The new extension to St Pancras to make room for Eurostar has resulted in the station losing much of its impact when seen from that once favourite haunt of the trainspotter – the platform ends. Bombardier Class 222/0 Meridian five-car DMU No. 222009 in revised Midland Main Line livery awaits the right of way under the soulless flat-roofed extension for MML services on 21 July 2007. But at least the livery of the Meridian looks dramatic!

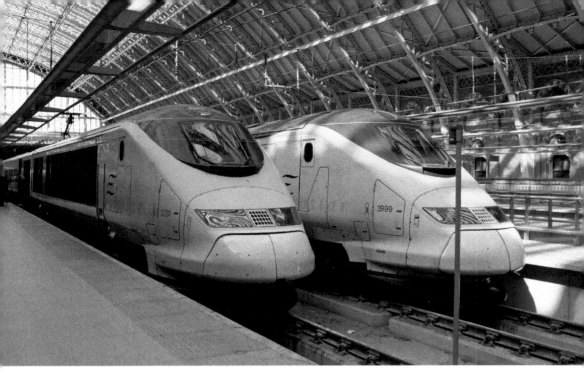

At least Continental travellers get to see St Pancras at its best. Underneath Barlow's beautifully restored roof are two GEC-Alstom/Brush/De Dietrich 3,000 V DC/25 kV AC/1,500 V DC tri-voltage Class 373/0 Eurostar Three Capitals ten-car half-set EMUs, No. 3231 (SNCF owned) and No. 3999 (a jointly owned spare set), at the buffers at St Pancras International, 1 April 2009.

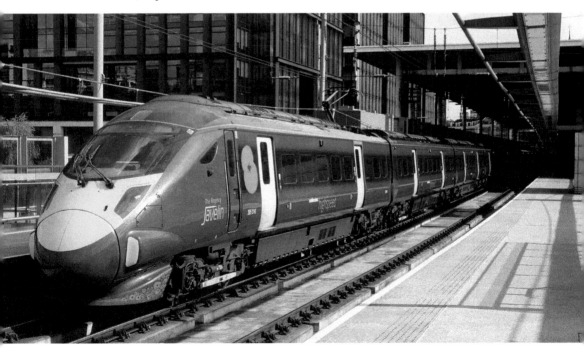

Hitachi (Kasado) Class 395 Javelin 25 kV AC overhead six-car EMU No. 395016 *Jamie Staff* of Southeastern in their blue livery at St Pancras, 2 September 2017. The set carries various emblems to commemorate the 'Somme 100' anniversary.

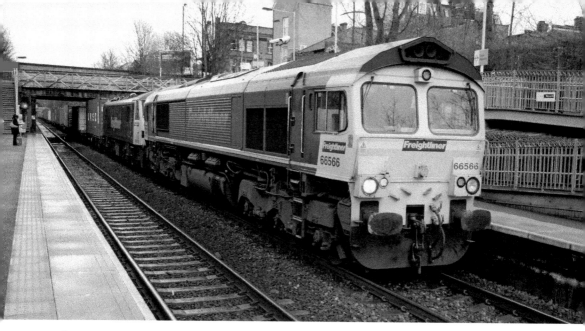

On 29 March 2010, GM Class 66/6 3,200 hp Co-Co No. 66566 of Freightliner hauls dead-in-tow BREL/GEC Class 90 5,000 hp Bo-Bo No. 90016 at Upper Holloway on a Trafford Park Freightliner container train, having been diverted over the then non-electrified Stratford–Gospel Oak line from the usual North London Line, which was undergoing extensive improvements at the time. Following the privatisation of BR's freight companies in 1996, Wisconsin Railways bought Transrail, Loadhaul and Mainline and amalgamated them into English, Welsh & Scottish Railway. EWS found that most of their newly acquired assets were old and had a very poor reliability record compared to North American standards. As a result, EWS bought a vast fleet of General Motors locomotives – the Class 66s – which have attained a standard of reliability never seen in the UK before. Other freight companies such as Freightliner followed EWS's example and likewise bought Class 66s.

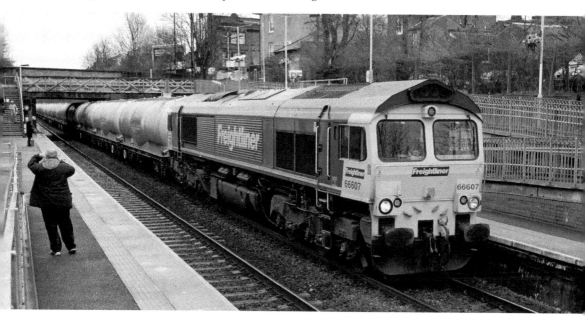

Another diversion from the North London Line, Freightliner GM Class 66/6 No. 66607 heads a West Thurrock–Earles empty Lafarge cement tanker train past Upper Holloway on 29 March 2010. Upper Holloway is on the Tottenham and Hampstead Junction line, originally a joint railway of the Midland and Great Eastern.

Chapter 5

Great Northern Lines

Opened in 1852 as the terminus of the Great Northern Railway, the simple, Italianate styling of Lewis Cubitt's King's Cross – a contrast to the Victorian neo-Gothic riot of neighbouring St Pancras – makes it one of the most aesthetically pleasing stations in London. Coupled with the presence of locomotives unique to the ECML – the powerful Deltic diesels in the past and now the 140 mph Class 91 electrics – the station is a strong attraction for the railway photographer. Interestingly, King's Cross is the only London terminus where both locomotives and HSTs can be seen in large numbers (discounting the loco-hauled sleepers from Paddington). But the introduction of the Hitachi Class 800 Azumas will soon be changing that.

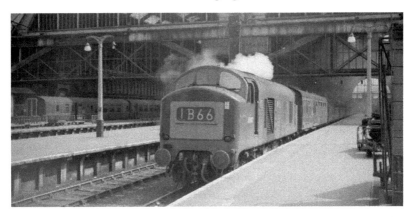

English Electric Type 2 (TOPS Class 23) Baby Deltic 1,100 hp Bo-Bo No. D5907 erupts in characteristic Deltic-engined fashion as it starts a Cambridge Buffet Express at King's Cross, July 1966. The loco, in BR green livery with light green stripe and yellow warning panel, was one of the Pilot Scheme builds. By this time it had been refurbished, with headcodes fitted and the redundant central gangways removed. Whereas the Class 23's 'big brother' Class 55 Deltics were one of BR's great successes, that success was not replicated in the smaller sibling. The Deltics required a great deal of specialised maintenance to keep their complex engines reliable and to perform at their best for the high-speed ECML services they operated – and they duly received such care. The Baby Deltics, on the other hand, were intended for more mundane mixed traffic duties and had to cope with the rough and tumble of such work without any of the mollycoddling the Class 55s received. The result was inevitable – chronic unreliability. Their availability was only a quarter of the contemporary BR Class 2 (Class 24). Even an extensive refurbishment scheme failed to make the retention of what were expensive assets worthwhile and they were withdrawn after a very short life. The first loco had entered service in 1959 and the last was withdrawn in 1971, except for one which remained in departmental use until 1975. English Electric produced many successful designs but the Class 23 was not one of them. Nonetheless, the current project to build a replica of what is a characterful design is welcome. Let us hope it is more reliable than the original.

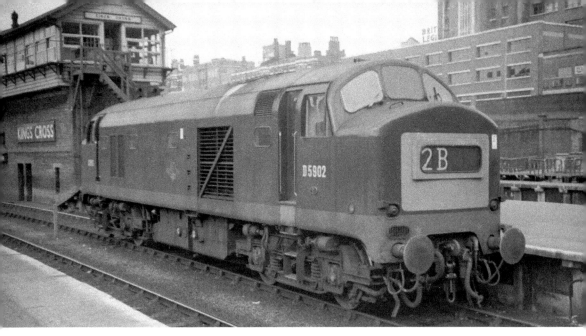

Refurbished English Electric Type 2 (Class 23) Baby Deltic No. D5902 is drawing into King's Cross to take out empty stock in July 1966. Perhaps it was a bit of a come-down for No. D5902 to be relegated to hauling empty stock rather than the Cambridge Buffet Car expresses.

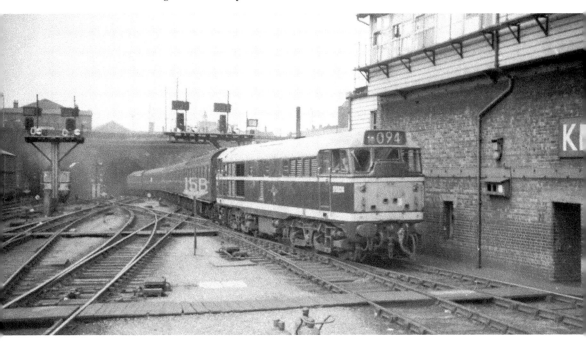

Brush Type 2 (TOPS Class 30) 1,250 hp A1A-A1A No. D5624 (later No. 31200) passes the once familiar, but now long gone, signalbox at King's Cross while arriving with an outer suburban service from Hertford North via Hitchen in July 1966. No. D5624 is one of the later batch with a headcode box above the cab and is in BR green livery with light grey stripes and small yellow warning panels. Initially the Class 30s proved very reliable and performed well – until failures of their Mirlees engines revealed a fundamental design flaw that BR considered too difficult and too costly to resolve (which some now dispute). Instead, the flawed Mirlees engine was replaced by a more robust and reliable English Electric one and the Class 30 was then reclassified to 31.

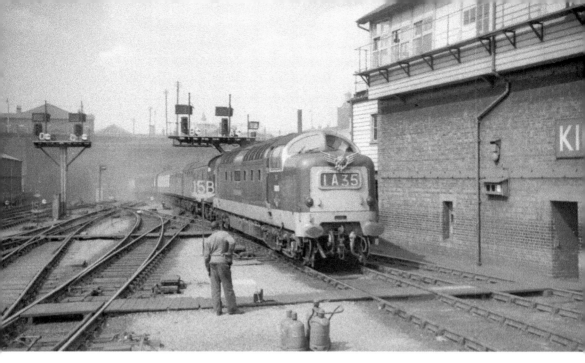

English Electric's finest – Type 5 (TOPS Class 55) Deltic 3,300 hp Co-Co No. D9013 *The Black Watch* (later No. 55013) in the livery which suited them best: Brunswick Green with a light green stripe (and a yellow warning panel), which broke up the slab sides of the Deltic. That is something the later overall Rail Blue failed to do. *The Black Watch* is seen in July 1966 entering King's Cross with 'The Flying Scotsman' from Edinburgh Waverley complete with the then new headboard. Unfortunately the headboard was carried for only a few years.

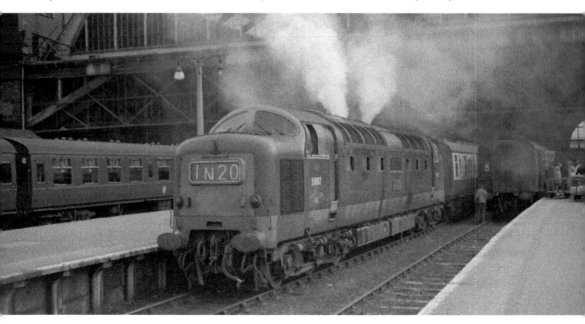

Making a good impression of a Saturn V taking off for the moon, English Electric Type 5 (Class 55) Deltic No. D9017 *The Durham Light Infantry* (later No. 55017) blasts off from King's Cross with an express for Leeds (not the Sea of Tranquillity) in July 1966. The complex Napier 1,650 Deltic D18-25 engines required a lot of careful maintenance but with that the Class 55s proved one of BR's greatest successes and represented a quantum leap in capability over previous diesel locomotives.

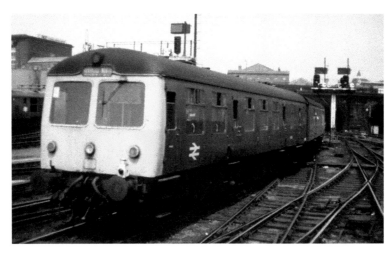

Departing King's Cross (Suburban) station on a Hertford North service in July 1975 is Cravens local passenger Class 106 two-car DMU Nos E50367 (Class 106) and E56123 (Class 141) of the 1956 batch without headcode panels. The main build of otherwise identical Cravens DMUs were equipped either with BUT L type (Leyland 680) engines in the Class 106 or BUT A type (AEC 220) engines in the Class 105. Both engines had an output of 150 hp and used identical mountings that would allow interchangeability of engines to facilitate maintenance. In the event, what happened was that all the Class 105s were refitted with BUT L type engines. Rather illogically, the now uniform class was redesignated 105 rather than 106. Although the Cravens units were designed for branch line and local stopping passenger services, the Eastern Region's sets were quickly moved to take over the King's Cross/Moorgate suburban services, for which they were ill-suited. They did not have enough doors to enable the quick boarding and alighting of masses of commuters while their engines had insufficient power to climb the bank out of the Moorgate 'Widened Lines' into King's Cross or the gradients out of King's Cross itself. The sets' acceleration was also less than ideal for busy suburban services. But they had to soldier on until electrification as there were no other DMUs available. Although Cravens had built sets (Classes 112 and 113) for the LMR with more powerful 235 hp Rolls-Royce CYNFLH engines, these tended to catch fire and the sets had a short life.

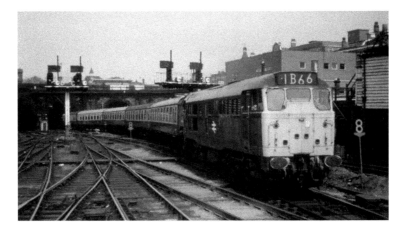

With the poor availability of the unreliable English Electric Type 2 Baby Deltics on the King's Cross outer suburban services to Hertfordshire and the Cambridge Buffet Expresses, other traction had to be found when BR eventually gave up on the Class 23s. The locomotives that replaced them were the Brush Type 2 A1A-A1As, which ironically – in original Class 30 condition with 1,360 hp Mirlees JVST engines – had also proved problematic. But re-engined with 1,470 hp English Electric 12SVT engines as Class 31, they proved not just more powerful than the Baby Deltics but far more reliable. Pictured is Class 31/1 No. 31184 (ex-No. D5607) arriving at King's Cross on a Cambridge Buffet Express in July 1975.

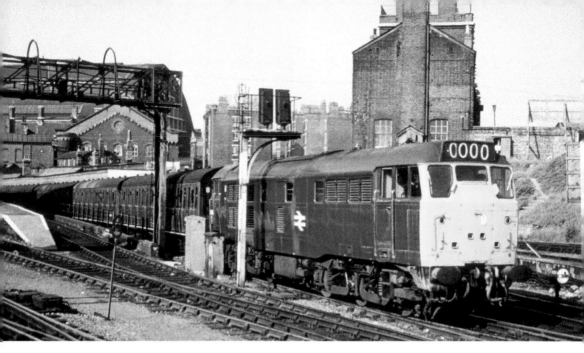

With the sun shining on a rather tatty Brush Type 2 pulling equally tatty coaches, the poor wearing properties of Rail Blue are shown to perfection. I thought the Class 31s looked smart in their original Brunswick Green livery enlivened with two light grey stripes whereas – even in good condition – the unrelieved Rail Blue with a slab of yellow covering the front of the cab looked bland and unimaginative. Pictured emerging out of the dark underworld of the 'Widened Lines' from Moorgate into the sunlit uplands of King's Cross on the Hotel Curve is Class 31/1 No. 31176 (ex-No. D5597) on a Welwyn Garden City service in June 1976. The King's Cross outer suburban services were the last workings on BR to employ BR Mk 1 loco-hauled non-corridor suburban stock and the last loco-hauled suburban service on BR, ending with electrification later that year.

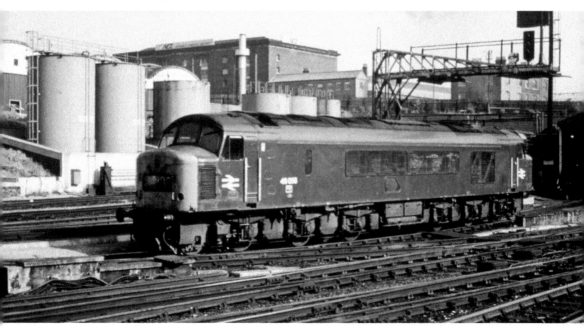

The immense length of the BR Type 4 (Class 46) Peak 1Co-Co1s is self-evident in this picture of No. 46038 (ex-No. D175) resting at King's Cross refuelling point, June 1976.

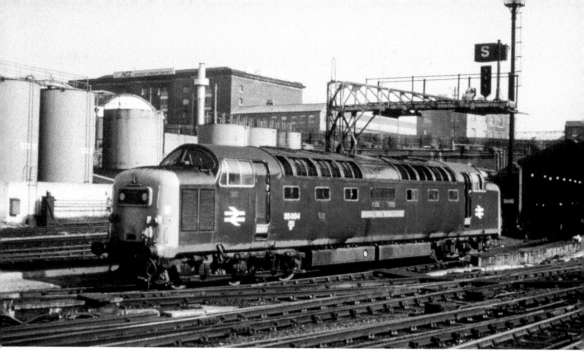

Another shot of a loco at King's Cross refuelling depot in June 1976. Seen here is English Electric Type 5 (Class 55) Deltic No. 55004 *Queen's Own Highlander* (ex-No. D9004). Bizarrely, a line of dirt at the bottom of the Rail Blue body makes it appear that the loco still has the light green stripe that the original green-liveried Deltics had! At least it relieves the blue mass of the loco. I thought Rail Blue looked particularly unsuitable on Deltics because of the deep body sides they had.

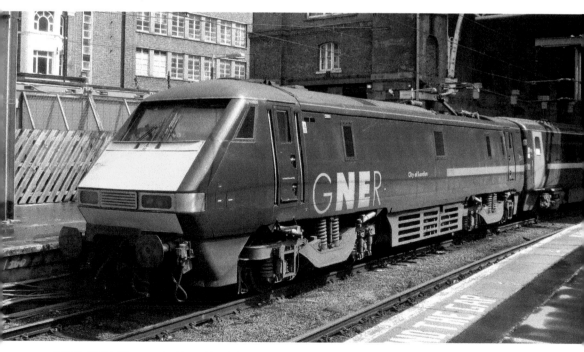

BREL/GEC Class 91 6,090 hp 25 kV AC overhead Bo-Bo No. 91101 *City of London* of GNER at King's Cross on an Edinburgh Waverley service, 21 July 2007. GNER's deep blue livery with a red stripe and gold lettering was one of the privatisation liveries I found particularly attractive.

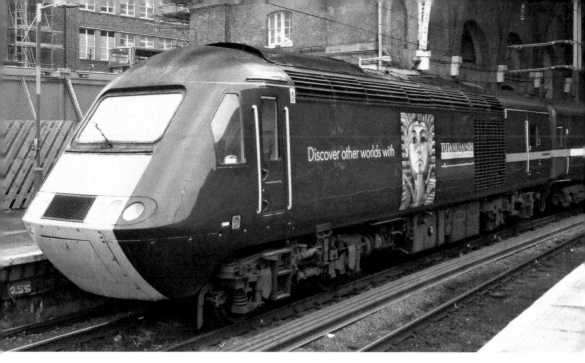

About to depart King's Cross on an Inverness service on 13 December 2007 is MTU-engined BREL Class 43/2 HST 2,250 hp Bo-Bo No. 43251 (ex-No. 43051) *Tutankhamun*. Curiously, it has no number visible. At this date the loco was operated by National Express East Coast but it is in debranded GNER livery with no NXEC branding visible at all. *Tutankhamun* was a former Midland Main Line locomotive that was refurbished by the GNER with a MTU engine and twin-light clusters.

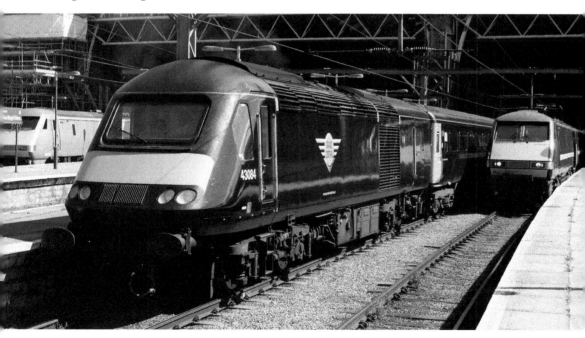

BREL Class 43/0 2,250 hp Bo-Bo No. 43084 of Grand Central at King's Cross on a Sunderland service, 30 June 2008. No. 43084 is one of a small batch refitted with buffers as a trial for a push-pull scheme with Class 91 electric locos when the ECML was first electrified. Unlike other operators, which re-engined their Class 43s with MTU or Paxman 12VP185 engines, Grand Central retained the original Paxman Valenta engines in their locomotives.

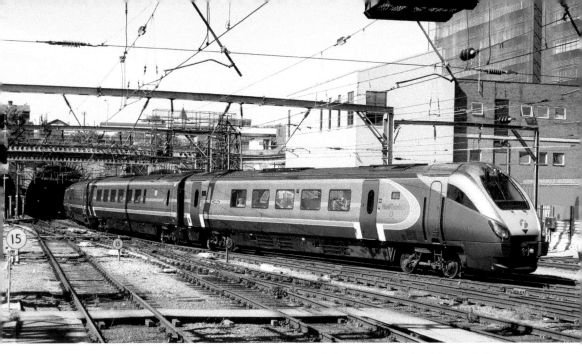

Emerging out of Gasworks Tunnel and creeping into King's Cross is Bombardier Class 222/1 Pioneer four-car DMU No. 222104 *Sir Terry Farrell* of First Hull Trains on a service from Hull, 30 June 2008.

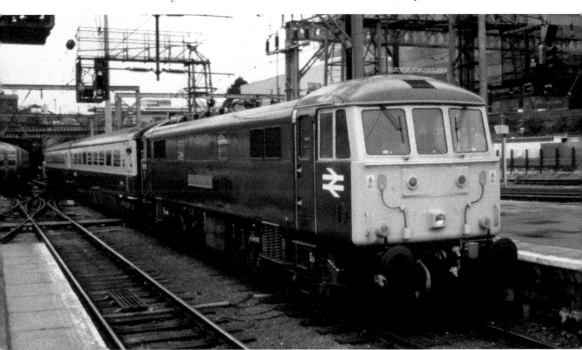

A very unusual visitor to King's Cross – BR/English Electric Class 86/1 5,000 hp Bo-Bo No. 86101 *Sir William A. Stanier FRS* (ex-Nos 86201 and E3191) of the AC Electric Group, rather amazingly brought out of preservation and hired to First Hull Trains after severe accident damage to one of their Class 222 Pioneer DMUs. This created a shortage of stock resulting in the substitution of Rail Blue and Grey Mk 3 loco-hauled carriages and the matching Class 86. *Sir William A. Stanier FRS* is seen departing King's Cross on a Saturday morning express to Doncaster, where there was a DMU connection to Hull, in February 2008.

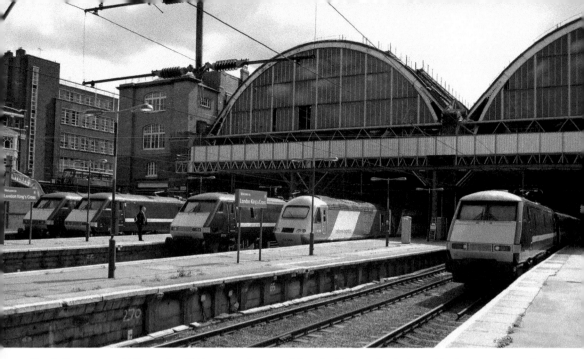

King's Cross station, 11 September 2009, seen at the start of the rebuilding work which would culminate in one of the finest stations in the country. On show is a solitary HST among a gaggle of Class 91s, all of National Express East Coast.

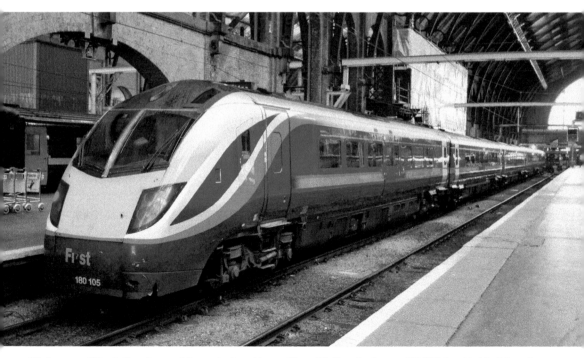

Under one of King's Cross's graceful trainsheds is Alstom Class 180 Coradia five-car DMU No. 180105 of Grand Central in debranded First Great Western livery (but still with 'First' on the coupling cover) after arrival from Sunderland, 11 November 2009. The Class 180s had recently been returned off lease by First Great Western (where the sets were known as Adalantes) to the ROSCO, who had then leased them to Grand Central, whose HSTs were feeling their age.

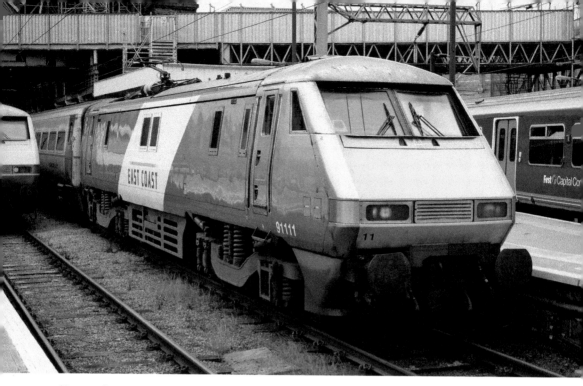

About to depart King's Cross on 30 August 2012 is BREL/GEC Class 91 6,090 hp Bo-Bo No. 91111 (ex-*Terence Cuneo*) of East Coast in re-branded National Express East Coast livery. No. 91111 was the only Class 91 to have been painted in full NXEC livery.

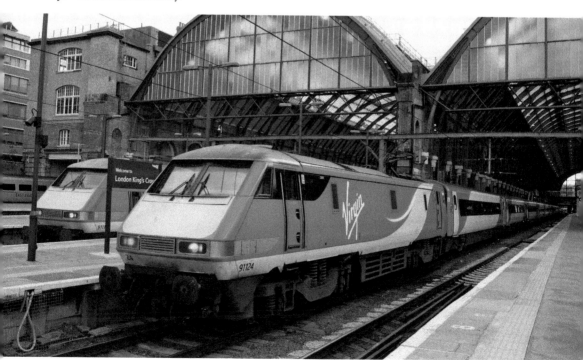

BREL/GEC Class 91 No. 91124 (ex-*Reverend W. Awdry*) of Virgin Trains East Coast at King's Cross is ready to depart on a northbound ECML service on 12 September 2015.

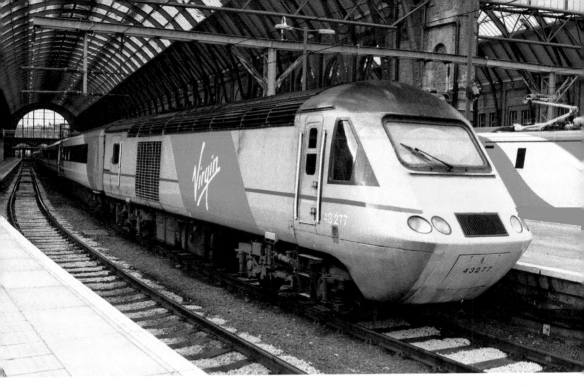

Seen at King's Cross on 12 September 2015 is Virgin Trains East Coast BREL MTU-engined Class 43/2 HST 2,250 hp Bo-Bo No. 43277 (ex-No. 43077 *County of Nottingham*) in VTEC-branded East Coast livery.

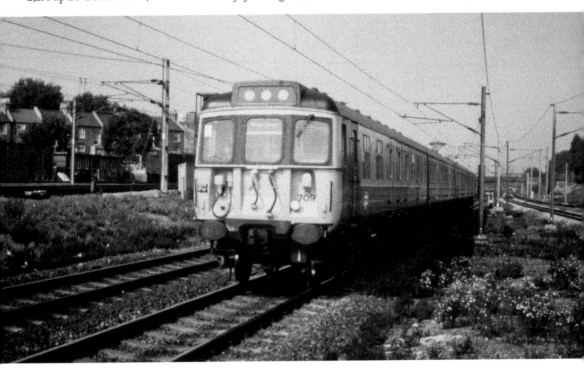

BR(ER) Class 312/0 25 kV AC overhead four-car outer suburban EMU No. 312709 (ex-No. 709) in Rail Blue and Grey livery approaches Finsbury Park on a Royston–King's Cross service, September 1982. The Class 312s were an update of the Class 310 (or AM10) but never got the AM12 classification it would have had pre-TOPS.

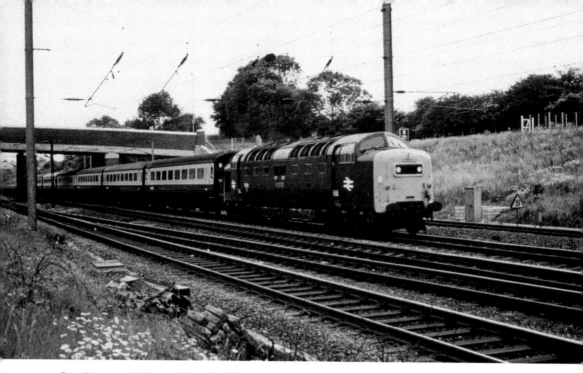

Speeding towards Potters Bar with a King's Cross–Newcastle express in June 1976 is English Electric 3,300 hp Class 55 Deltic Co-Co No. 55012 (ex-No. D9012) *Crepello* in Rail Blue livery. Many Deltics carried on the LNER tradition of naming their top express locomotives after racehorses and, although most were meaningless, they somehow conveyed a powerful, speedy impression, and in my view *Crepello* was just such a name.

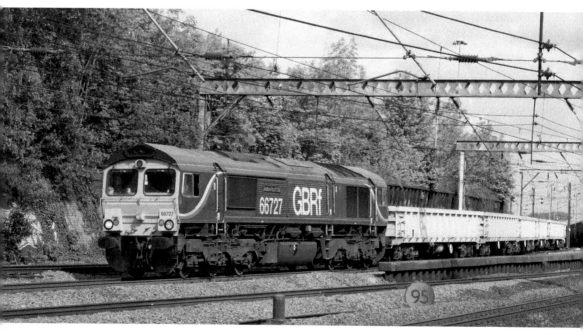

GM Class 66/7 3,200 hp Co-Co No. 66727 *Andrew Scott CBE* of GBRf in First GBRf livery creeps along on a Network Rail ballast train at Haringey, 12 May 2014. The Class 66s' nickname of 'sheds' aptly describes their looks. Excellent locomotives though they undoubtedly are, their North American lineage and plain – even ugly – appearance do not make them as appealing to me as older British-built locos.

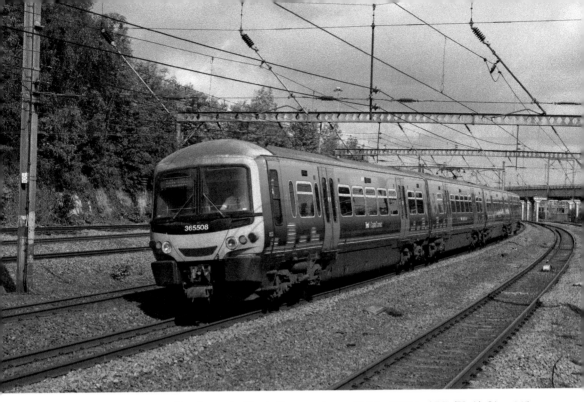

Fast approaching Haringey on a Peterborough–King's Cross service on 12 May 2012 is ABB (York) Class 365 Networker Express 25 kV AC four-car EMU No. 365508 of First Capital Connect in 'urban lights' livery.

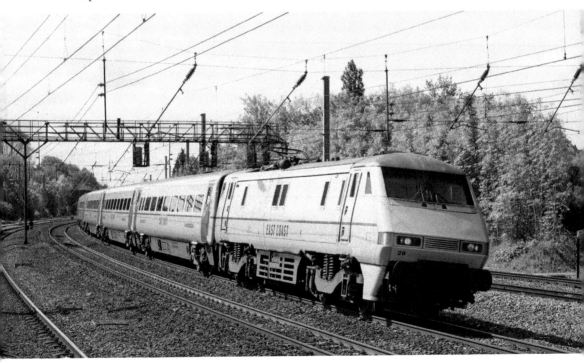

BREL/GEC Class 91 6,090hp Bo-Bo No. 91128 (ex-*Peterborough Cathedral*) of East Coast, in their striking silver-grey livery, sweeps through Haringey on a northbound ECML service, 12 May 2014.

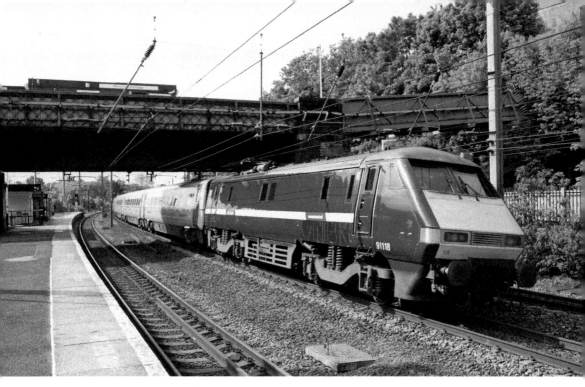

BREL/GEC Class 91 No. 91118 (ex-*Bradford Film Festival*) of East Coast in EC-branded interim National Express East Coast livery at Haringey on a King's Cross-bound ECML service, 12 May 2014. This was the last Class 91 in (originally GNER) blue livery and was repainted very soon after this photo was taken.

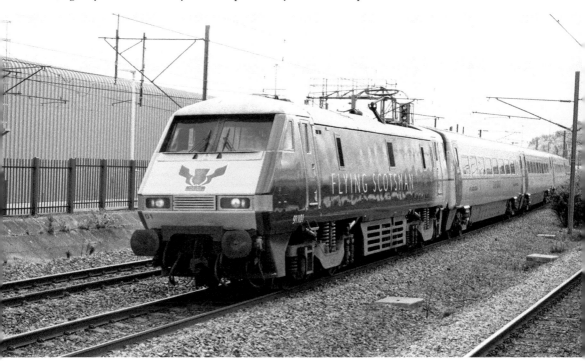

In its unique Flying Scotsman purple livery, BREL/GEC Class 91 No. 91101 (ex-*City of London*) of East Coast is seen passing Hornsey on a northbound ECML service, 12 May 2014.

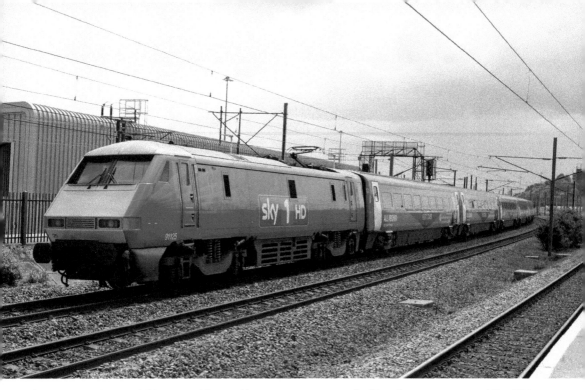

Another uniquely liveried Class 91 was No. 91125 (ex-*Berwick-upon-Tweed*) of East Coast in promotional Sky 1HD blue livery. It is seen here hauling a set in the same Sky livery at Hornsey on a King's Cross-bound ECML service on 12 May 2014.

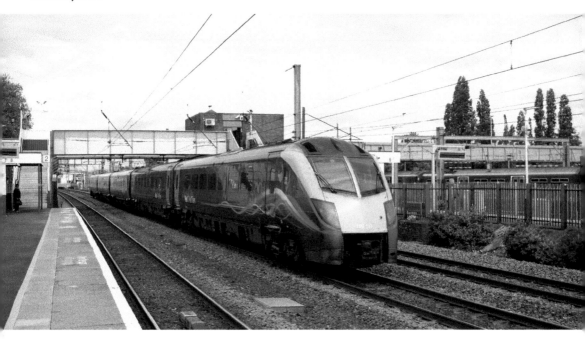

Passing Hornsey on a King's Cross–Hull service on 7 May 2014 is Alstom (Washwood Heath) Class 180 Adelante five-car DMU No. 180110 of First Hull Trains in their 'dynamic lines' livery. The Class 180s had a prolonged service entry due to poor reliability and even when they entered full-squadron service they were plagued by problems. The Class 180s are the only high-speed diesel-hydraulic DMUs in the world.

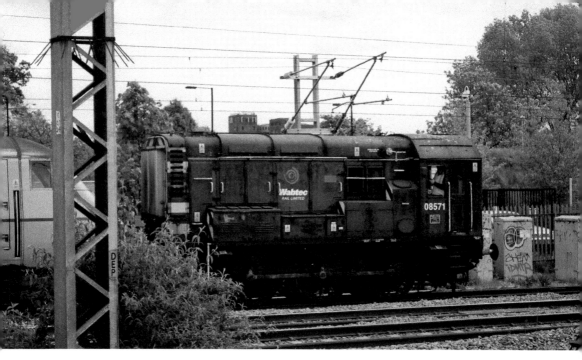

These days, the increasing profusion of buddleia growing on railway land is the bane of railway photographers. It is difficult enough taking photographs of shunters as it is without buddleia partly obscuring your subject, but that is what happened when I photographed BR/English Electric Class 08 400 hp 0-6-0 No. 08571 (ex-No. D3738) shunting an East Coast Mk 4 set at Bounds Green TMD, 12 May 2014. The Class 08 shunters, once ubiquitous, are now very rare outside preservation. No. 08571 belongs to Wabtec and is in their black livery – although note the surviving outline of the BR double arrow symbol on the battery box!

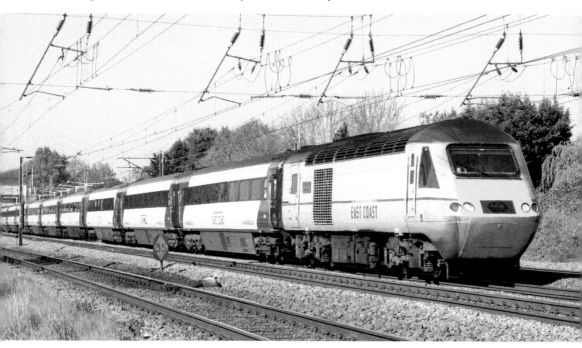

Racing past Brookman's Park on a Newark (North Gate)–King's Cross service on 16 April 2014 is MTU-engined BREL Class 43/2 HST No. 43367 (ex-No. 43167 *Deltic 50 1955–2005*) of East Coast.

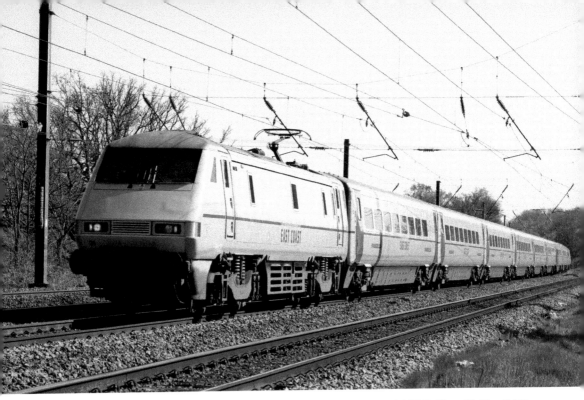

A northbound ECML service speeds passed Brookman's Park behind BREL/GEC Class 91 No. 91121 (ex-*Archbishop Thomas Cranmer*) of East Coast in their silver-grey livery on 16 April 2014.

Overtaking a freight at Brookman's Park is Alstom Class 180 Zephyr ('Adelante' being a First Group brand) five-car DMU No. 180101 of Grand Central in its black and orange livery on a King's Cross–Bradford service, 7 May 2014.

GM Class 66/7 3,200 hp Co-Co No. 66731 *Interhub GB* of GBRf on a gypsum freight at Brookman's Park, 16 April 2014.

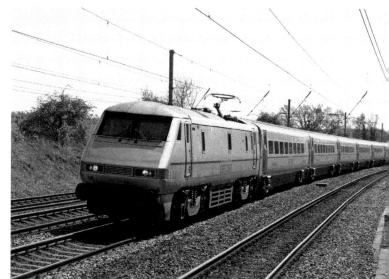

A northbound ECML service approaches Welham Green headed by East Coast's BREL/GEC Class 91 No. 91109 (ex-*The Samaritans*), 16 April 2014.

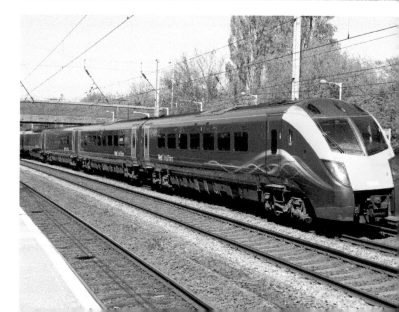

Hurtling through Welham Green is Alstom Class 180 Adelante five-car DMU No. 180109 of First Hull Trains in their 'dynamic lines' livery on a Hull–King's Cross service, 16 April 2014.

Chapter 6

North London Lines

Its very existence now seems forgotten and Broad Street was one of London's lesser known termini even before it was demolished in 1986 to make way for the Broadgate/ Liverpool St complex. Opened in 1865 by the North London Railway as the terminus of a small but very busy suburban network, decline had set in even before the First World War. Electrification of its services in 1916 stemmed the decline for a while but after the Second World War the decline resumed. When I visited Broad Street between the late 1960s and the early 1980s it seemed to be a ghost station with few passengers outside peak hours. But it was very characterful and its faded grandeur – well, perhaps not quite grandeur – added to its attraction. Moreover, the low frequency of services at Broad Street made recording and photographing trains here a rather soporific affair compared to doing the same at the incredibly busy Liverpool Street next door.

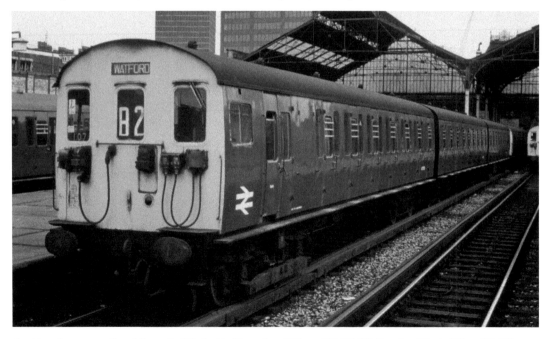

Awaiting departure at Broad Street for Watford in December 1975 was BR (LMR) 'London District' Class 501 BR Mk 1 inner suburban three-car EMU set No. 501107; curiously, the only set identification is in the front window. The set, in the drab overall Rail Blue, was composed of cars Nos M61107, M70107 and M751107. The North London Line was originally electrified on the 630 V DC four-rail system, but was later converted to three rails and 750 V DC.

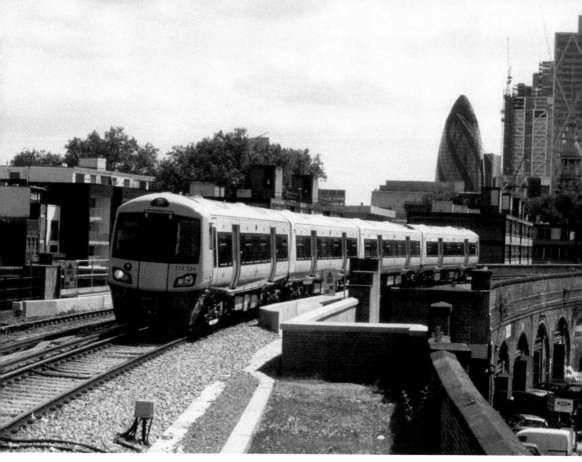

With the 'Gherkin' and the City prominent in the distance, Bombardier Class 378/2 (ex-378/0) Capitalstar 750 V DC third rail four-car EMU No. 378226 of London Overground leaves Hoxton on an East London Line Dalston Junction–New Cross Gate service, June 2010. This unit was built as three-car Class 378/0 set No. 378026 and was later strengthened with a fourth car, reclassified and renumbered.

Chapter 7

Great Eastern Lines

Liverpool Street station was first opened in 1874 by the Great Eastern Railway and then greatly expanded in the 1890s. It was in effect two separate stations with only a narrow walkway between the two. It was completely rebuilt into a far more efficient and user-friendly station in 1993. However, I always found the old station very atmospheric. In the days before electrification of the main lines, it was the only London station where English Electric Type 3s (Class 37s) could be found on main line expresses.

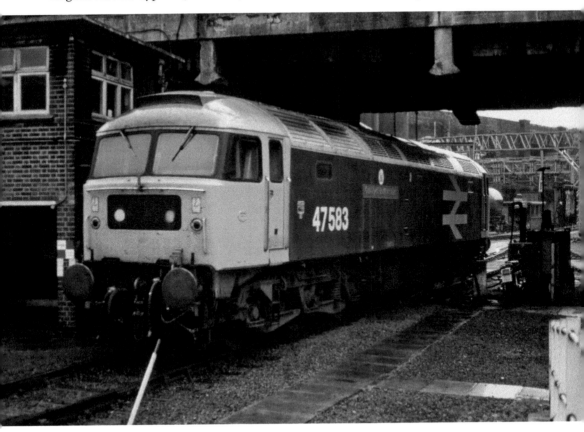

Brush Class 47/4 2,580 hp Co-Co No. 47483 *County of Hertfordshire* in BR Large Logo Rail Blue livery and silver roof at Liverpool Street, August 1982. This loco had previously been numbered 47172 and before that D1767. It was subsequently renumbered 47734; it was also rather snappily named *Crewe Diesel Depot Quality Approved*.

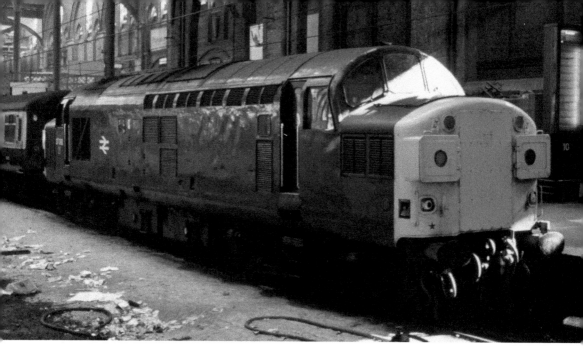

A ray of sun catches the nose of English Electric Class 37/0 1,750 hp Co-Co No. 37092 (ex-No. D6792) with split headcodes and blocked-up central headcodes in standard Rail Blue livery at Liverpool Street, August 1985.

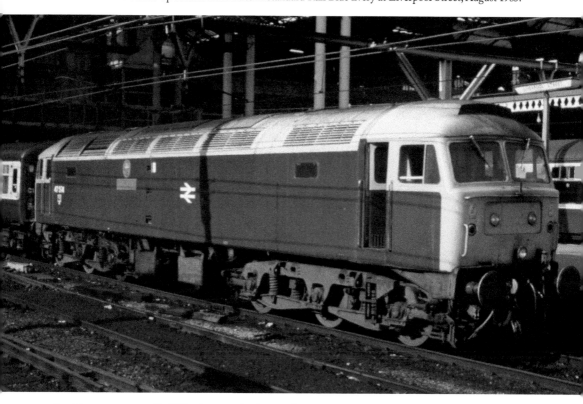

Looking very smart in Rail Blue livery with silver roof is Brush Class 47/4 No. 47574 *Lloyds List 250th Anniversary* as it rests between duties at Liverpool Street, August 1985. This loco had been numbered 47174 and D1769, while it was later No. 47729 *Benjamin Gimbert GC*.

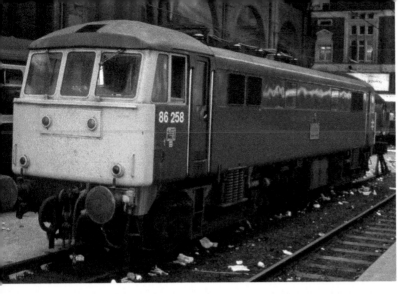

With rays of sun above peeping through Liverpool Street's windows, BR/ English Electric Class 86/2 (originally Class AL6) 25 kV AC 3,600 hp Bo-Bo No. 86258 *Talyllyn* takes a break on a sultry August day in 1985. As built, this loco had been numbered 86046 and it was later renamed *Ben Nevis*.

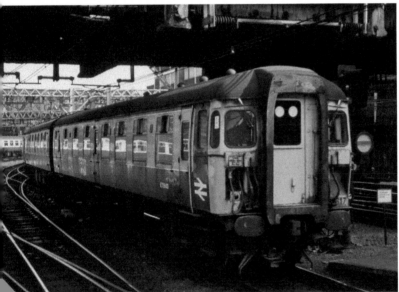

BR(ER) Class 309/2 (originally Class AM9/2) 25 kV AC 'Clacton Buffet' Inter City four-car EMU No. 309617 (ex-No. 617) arriving at Liverpool Street in August 1985. The AM9s, which used the Mk 1 coach body, were the first AC express EMUs built for BR and the first capable of 100 mph. The AM9/2s were a sub-class equipped with a buffet car. In those days, both restaurant cars and buffet cars were still common on BR services.

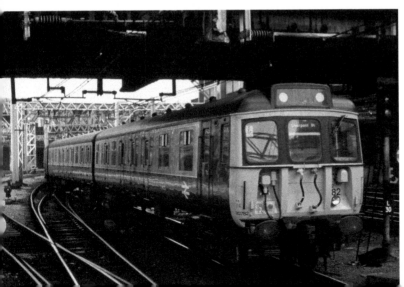

Taken from the same vantage point as the preceding photograph, BR(ER) Class 312/1 four-car outer suburban EMU No. 312782 (ex-No. 782) in Rail Blue and Grey livery departs Liverpool Street in August 1985. The Class 309s employed the Mk 2 bodyshell – the last EMU design on BR to do so – and were also the last to have slam doors.

Under the magnificent roof of the west side of Liverpool Street – which fortunately was retained and restored in the rebuilding – BREL/ GEC Class 90 5,000 hp Bo-Bo No. 90002, branded ONE Anglia, rests after completing its run from Norwich on 21 July 2007. ONE's coloured strips at each end of their locomotives and multiple units added to the impact of their livery.

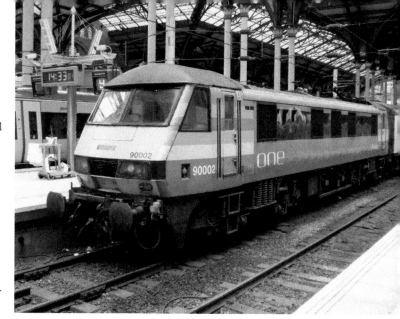

Also at the west side of Liverpool Street is No. 90015 *Colchester Castle* of Greater Anglia although it is still in the livery of the previous franchisee, National Express East Anglia; Greater Anglia's branding is the only identification carried to identify its operator. *Colchester Castle* has just arrived on an express from Norwich, 30 August 2012.

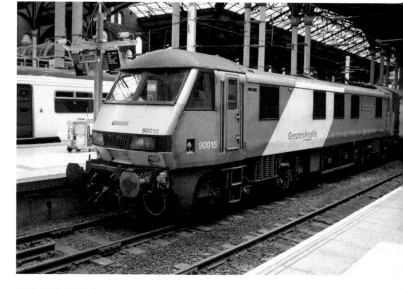

The Docklands Light Railway's station at Pudding Mill Lane offered some excellent views of passing trains to and from Liverpool Street. Seen here is Siemens Class 360/0 Desiro outer suburban four-car EMU No. 360105 of ONE but in First Great Eastern livery (without the 'First' branding) on a Clacton– Liverpool Street service, 3 October 2007.

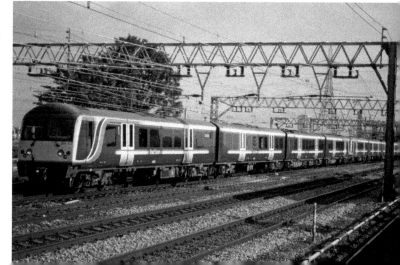

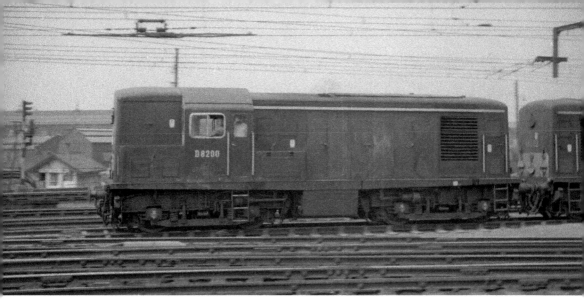

Speeding past Stratford MPD in July 1966 is British Thomson-Houston Type 1 (later Class 15) Bo-Bo No. D8200 of the Pilot Scheme batch in green livery. The loco is on a double-headed freight with sister No. D8202. Interestingly, No. D8202 has its number on the nose. BTH were the lead contractor for this class, which was built by Yorkshire Engine and Clayton. Their V16 Paxman YHXL engine was a rather complex unit considering its output was only 800 hp and, being maintenance-intensive, it proved unreliable in the hurley-burley world of freight haulage. Despite this being apparent with the Pilot Scheme batch, so urgent was BR's perceived need to replace steam that the Class 15 was put into production alongside its far more reliable rival – the English Electric Type 1 (Class 20). Inevitably, the Class 15s had a short, unhappy life whereas several Class 20s are still in service today – hopefully after a happy life! Whatever its faults, to my eyes the Class 15 was the most attractive of the various Type 1 designs.

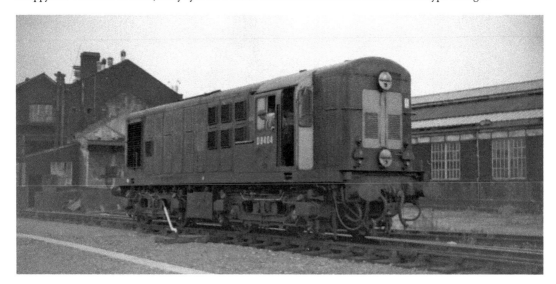

Another Type 1 design produced for BR's Pilot Scheme was the North British Type 1 (later Class 16) 800 hp Bo-Bo. The class shared the same 800 hp V16 Paxman YHXL engine as the BTH Class 15 and suffered similar problems. However, the Class 16 proved even more maintenance-intensive than their BTH competitors and so unreliable was the class that not even BR's urgent need to replace steam locomotives led to the Class 16s being put into production, in contrast to their Class 15 and 20 competitors. As a result, the Class 15s had a very short life. To me, with its multiplicity of grilles and rather square edges, the Class 16 was the least attractive of BR's Type 1 designs. Photographed in July 1966, No. D8404, in green livery with a yellow warning square, is pottering about Stratford TPD. At least it is in motion.

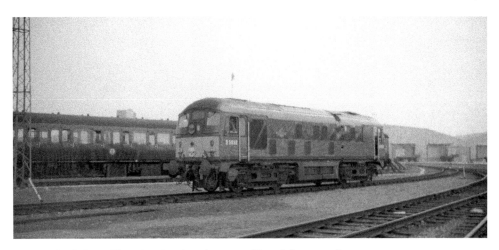

For its Pilot Scheme BR ordered no less than seven Type 2 designs – the most in any power category – and put into production the products of four manufacturers: North British (Classes 21 and 22), Birmingham Railway & Carriage Co. (Classes 26 and 27), Brush (Class 30, later 31) and BR's own works (Class 24 and, with Beyer Peacock, the Class 25). In retrospect, it is difficult to see the justification for building such large numbers of modestly powered locomotives at a time when freight traffic was rapidly declining and the flexibility of multiple units was proving highly suitable for many passenger duties. As a result, changing times would render many Type 2 designs' lives shorter than they should have been. The illustration shows BR Type 2 (later Class 24/0) 1,160 hp Bo-Bo No. D5038 (later No. 24038) at Stratford TMD in July 1967. Its rather fussy design with a multiplicity of body-side grilles is somewhat compensated for by BR's attractive two-tone green livery (with small yellow warning panels).

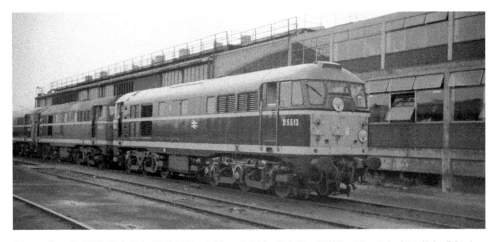

Also at Stratford TMD in July 1967 is Brush Type 2 A1A-A1A No. D5513 with original 1,250 hp Mirrlees JVS12T engine and hence classified 30 under TOPS. No. D5513 is an early build from the Pilot Scheme batch; it is thus without headcode boxes but with central gangways. It is in a somewhat hybrid livery of BR green livery with light grey stripes and small yellow warning panel but with the then new BR double arrow symbol normally associated with blue examples. Unlike their production sisters with uprated 1,365 hp Mirrlees engines, the Pilot Scheme batch never had any trouble with their engines and were thus the last to be refitted with 1,470 hp English Electric 12SVT engines (and reclassified 31) in 1969. It does call into question BR's decision to embark on a very expensive programme of replacing all the Mirrlees engines in the Class 30s rather than simply derating all the production batches to 1,250 hp. But having said that, the more powerful English Electric-engined Class 31s have given long and sterling service – with the last examples only recently being withdrawn from normal service. No Class 30s ever got their new TOPS numbers in the 30 series. No. D5513 became Class 31/0 No. 31013.

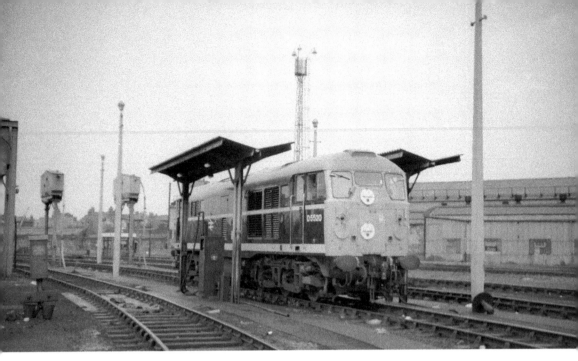

Brush Type 2 A1A-A1A (TOPS Class 31/1), as re-engined with a 1,470 hp English Electric engine, No. D5520 (later No. 31102) is in a hybrid green livery with light grey stripes and all yellow front end but with the new BR double arrow symbol. The locomotive is at the refuelling point at Stratford TMD in July 1967. No. D5520 was the first production Brush Type 2 (as a Class 30 with a 1,360 hp Mirrlees engine at that time) after the Pilot Scheme batch. It had no headcodes but had central gangways.

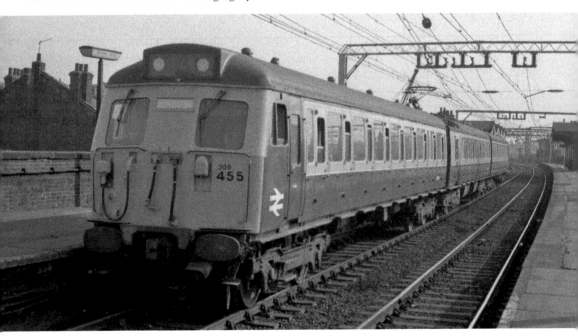

One of my favourite vantage points in London over the years has been Bethnal Green. In this photograph, BR(ER) Class 308/3 (originally Class AM8/3) 25 kV AC three-car outer suburban EMU No. 308455 (ex-No. 455) in Rail Blue and Grey livery is on a Liverpool St–Chingford service in September 1982. The Class 308 employed the Mark 1 bodyshell but had the later sloping cab that was such an improvement aesthetically over the slab fronts of earlier EMUs.

The English Electric Type 3 (Class 37) 1,750 hp Co-Cos were long associated with the Liverpool Street–Cambridge expresses and No. 37099 (ex-No. D6799) is on such a duty as it surmounts Bethnal Green Bank and powers through the station in September 1982. No. 37099 is one of the earlier builds of this numerous class, with split headcode boxes flanking a central gangway. It is in Rail Blue livery with all yellow front ends.

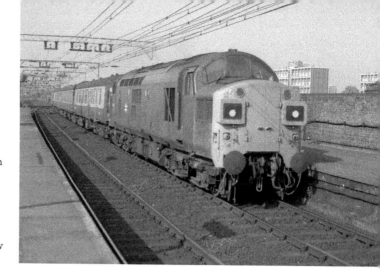

Speeding past Bethnal Green is Brush Class 47/0 No. 47012 (ex-No. D1539) with a mixed rake of Mk 1 and early Mk 2 coaches on a Norwich–Liverpool St service, September 1976.

BR(ER) Class 309/2 (originally Class AM9/2) Clacton Express InterCity four-car EMU No. 615 (later No. 309615) passes Bethnal Green on a Liverpool St–Clacton/Walton service, September 1982.

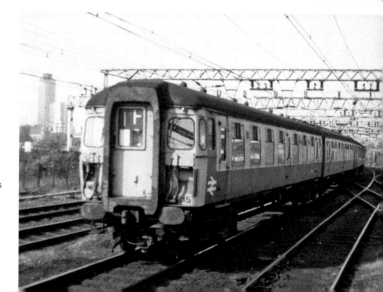

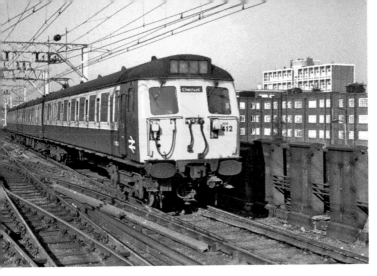

Surmounting Bethnal Green Bank on a Liverpool St–Cheshunt service is BR(ER) Class 305/1 (originally Class AM5/1) three-car outer suburban EMU No. 305412 (ex-No. 412), September 1982.

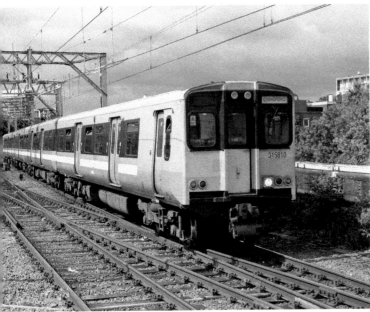

The same location as the previous photograph, thirty years later! BREL (York) Class 315 four-car EMU No. 315810 of Greater Anglia in GA-branded Interim National Express East Anglia livery is on a Liverpool St–Chingford service, 30 August 2012.

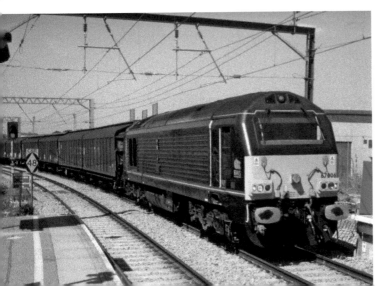

Royal Claret-liveried Alstom Class 67 3,300 hp Bo-Bo No. 67006 *Royal Sovereign* of EWS on a rather more prosaic duty than hauling the Royal Train. *Royal Sovereign* is paused at signals at Stratford on an Ely–Dollands Moor Cargowaggon service, 1 July 2008.

No. 66412 is a low emissions variant of GM's Class 66/4 3,200 hp Co-Co. No. 66412 is an EWS locomotive but is in Malcolm Rail livery and it is pictured passing through Stratford on a Tilbury–Daventry intermodal on 19 November 2008.

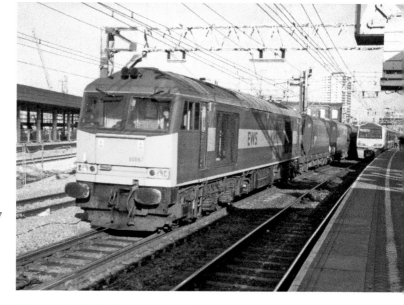

Brush Class 60 3,100 hp Co-Cos are not often seen at Stratford. Here No. 60087 *Barry Needham* of EWS is at the head of a Marks Tey–Hothfield empty hoppers train in November 2008.

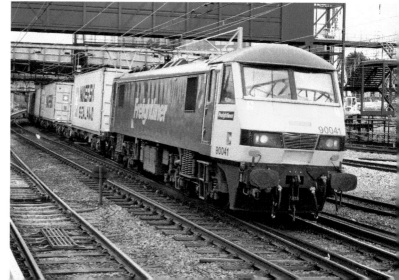

BREL/GEC Class 90 No. 90041 in the now superseded Freightliner dark green livery thunders through Stratford on a Felixstowe–Trafford Park Freightliner container train on 17 June 2009.

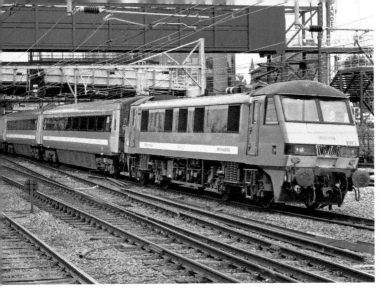

When National Express East Anglia took over the franchise previously operated by ONE, they hurriedly adopted an interim livery, adapting ONE's blue and black livery by removing the coloured stripes at the cab ends and adding a bodyside white stripe with National Express branding. In just such a livery, BR/GEC Class 90 No. 90002 (formerly *The Girl's Brigade* and previously *Mission Impossible*) sweeps through Stratford on a Norwich–Liverpool St service, 17 June 2009.

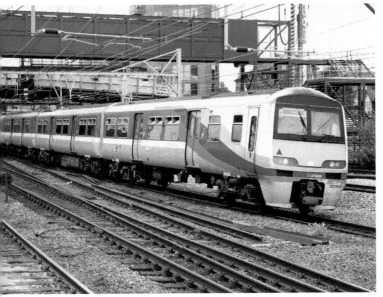

Building work in association with the London Olympics and the Westfield Shopping Centre looms above BREL (York) Class 321/3 four-car EMU No. 321346 of National Express East Anglia in NXEA-branded Great Eastern livery at Stratford on a Clacton–Liverpool St service, 17 June 2009. This livery was another interim one adopted by NXEA.

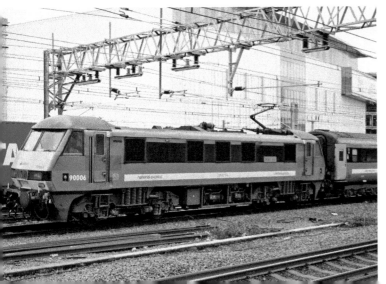

BREL/GEC Class 90 No. 90006 *Modern Railways – Roger Ford* (ex-*High Sheriff*) passes Stratford at speed on a Norwich–Liverpool St express, 29 March 2010. No. 90006 is in an interim NXEA livery, which is a modified and rebranded ONE livery.

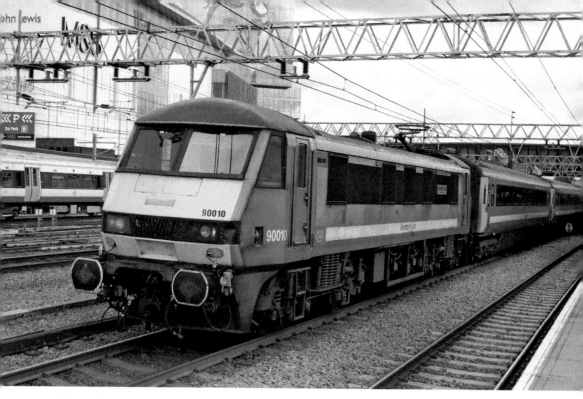

Passing Stratford is BREL/GEC Class 90 No. 90010 *Royal Anglian Regiment* of Greater Anglia in GA-branded interim National Express East Anglia livery on a Norwich–Liverpool St express, 30 August 2012.

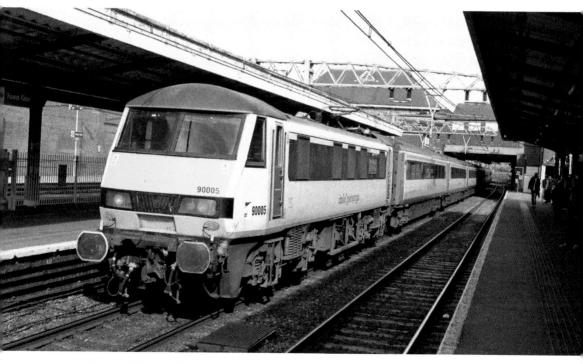

The rather bland livery of Abellio Greater Anglia is displayed on BREL/GEC Class 90 No. 90005 *Vice-Admiral Lord Nelson* on a Liverpool St–Norwich express as it speeds through Forest Gate, 13 September 2015.

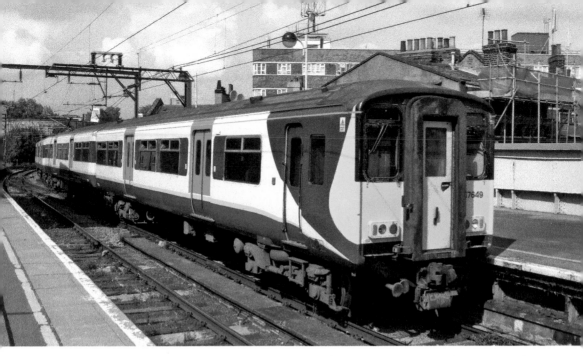

BREL (York) Class 317/6 four-car EMU No. 317649 (ex-No. 317249) of National Express East Anglia, amazingly still in West Anglia Great Northern white, blue and grey livery, but with NXEA branding, at Hackney Downs on a Liverpool St service, 29 August 2007.

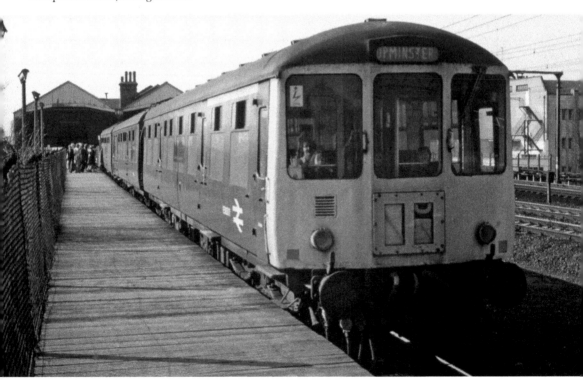

Out in the sticks! Birmingham RC&W Co. Class 104 three-car Local Passenger DMU comprising cars Nos E50571 (Class 104/1), E59220 (Class 166) and E50555 (Class 104/1) of the 1958 batch at Romford on an Upminster service, March 1976. Note the wooden platform.

Chapter 8

London, Tilbury & Southend Lines

Fenchurch Street was first opened in 1841 but the present station was built in 1854 by George Berkley as the terminus of the London, Tilbury & Southend Railway. Somewhat like Broad Street, it was a station purely devoted to suburban services; unlike Broad Street, the services at Fenchurch Street became busier and busier and the station continues to be very busy. Although once known as the 'misery line' today, under the curiously named 'C2C', the London, Tilbury & Southend line services are performing extremely well in terms of punctuality and customer satisfaction. However, for the railway enthusiast the fact that only one class of EMU (Class 357) dominates on LT&S lines makes for less interest than elsewhere in London. And it was little better in the days before privatisation when the Class 302 EMUs dominated the scene, occasionally leavened by EMUs cascaded from other lines.

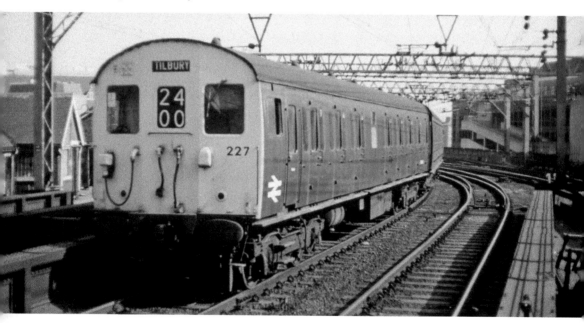

Fenchurch Street is one of London's smaller – but nonetheless extraordinarily busy – stations. The Eastern Region's Class AM2 (TOPS Class 302) four-car outer suburban EMU was typical of the rather unimaginative styling of BR's Mk 1-bodied EMUs. The class was originally built for the 1,500 V DC overhead London, Tilbury & Southend lines but when these were converted to the 25 kV AC overhead system, so were the AM2s. No. 227 (later No. 302227) is departing Fenchurch Street on a Tilbury service, March 1976.

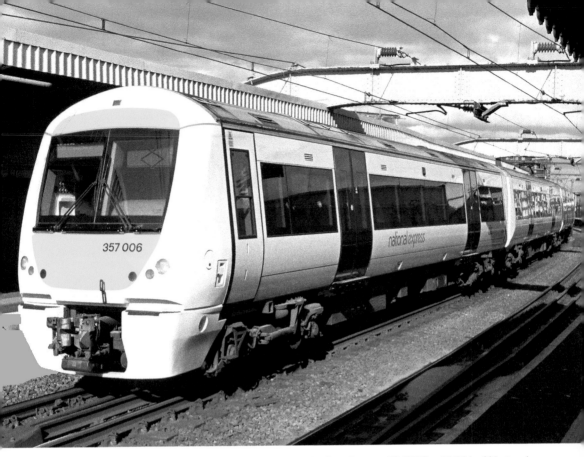

Adtranz Class 357/0 Electrostar 25 kV AC overhead outer suburban four-car EMU No. 357006 of National Express/C2C in their then new livery on a Fenchurch Street–Grays service at Limehouse, 15 March 2010. In BR days, attempts at painting stock in a predominantly white livery would have been doomed to failure, bearing in mind the unkempt state much of the stock got into, but under privatisation there is no denying that it is rare to see dirty stock. And No. 357006 is no exception.

Chapter 9

South Eastern Lines

With major stations at London Bridge, Canon Street, Blackfriars, Charing Cross, Victoria and, at one time, Holborn Viaduct, the former South Eastern & Chatham Railway offered many interesting locations for railway photography. However, unlike those stations north of the Thames, those on the South Eastern offered little opportunity for photographing loco-hauled passenger trains once steam had been banished. Nevertheless, the variety of multiple units has always been great.

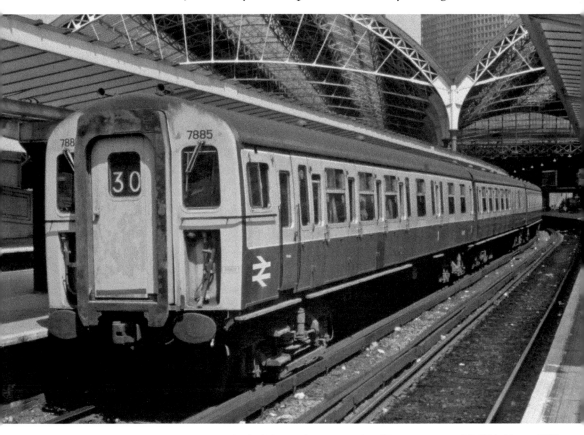

Emerging out of the impressive trainshed of the south-eastern side of Victoria station, BR(SR) Class 4-VEP (TOPS Class 423/0) outer suburban four-car EMU No. 7885 (later No. [42]3185) departs on a Dover Priory service, July 1975. Unlike the lines north of the Thames, those to the south operate on the 750 V DC third rail system.

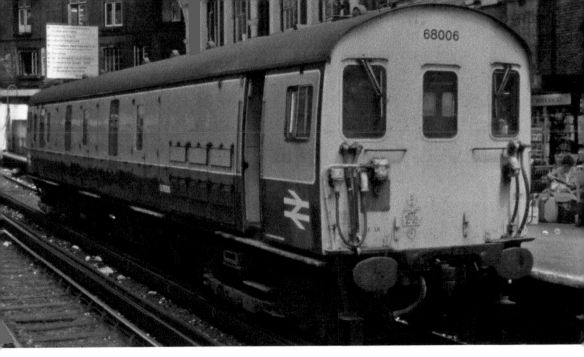

In the days of boat trains, so much luggage was carried that dedicated luggage vans were attached to the coaches in steam days or to the EMUs in electric days. Seen at Victoria (south-eastern side) in August 1975 is BR(SR) Class 419 (originally Class AF-1) Motor Luggage Van No. 68006, which has arrived at the head of a 4-CEP/4-BEP/4-CEP formation on a boat train service from Dover (Marine). As well as working on the 750 V DC third rail system, the MLVs were fitted with batteries in order to work on unelectrified sidings.

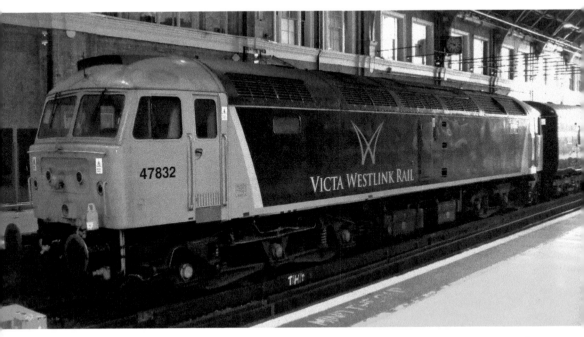

A uniquely liveried Brush – Class 47/4 2,580 hp Co-Co No. 47832 (formerly Nos 47560, 47031 and D1610 and previously named *Solway Princess*, *Driver Tom Clark OBE* and *Tamar*) of Victa Westlink Rail. This was a very short-lived company with just this one locomotive. It has brought empty stock into Victoria for an excursion on 10 December 2007.

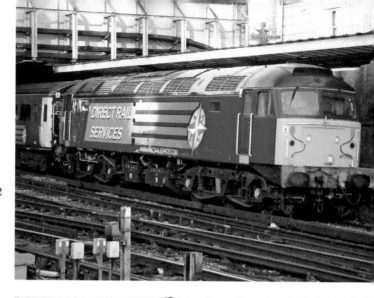

At the head of the excursion stock seen in the previous photograph, Brush Class 47/7 No. 47790 (previously Nos 47673, 47593, 47272 and D1973 and named *Galloway Princess*, *Saint David*, *York Inter City Control* and *Galloway Princess* again) of Direct Rail Services in their then new 'Compass' livery, 10 December 2007.

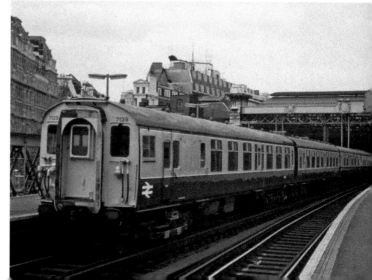

Departing Victoria is Bombardier Class 375/3 Electrostar express four-car EMU No. 375308 of Southeastern, 5 June 2008. The Electrostar family has proved immensely successful for Adtranz and Bombardier and have had a very long production run – from 2001 to the present day.

BR(SR) Class 4-CEP (TOPS Class 411/2) express four-car EMU No. 7139 at Charing Cross, May 1975. The 4-CEPs (and sister buffet-equipped 4-BEPs) were BR's first main line express EMUs, employing the Mk 1 body. They replaced the steam-hauled expresses on the Kent Coast Main Line.

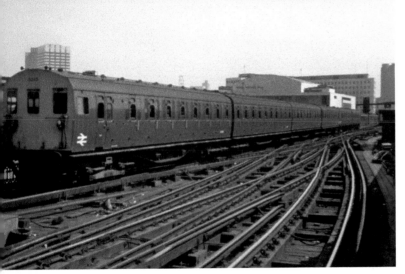

Employing Bulleid's body rather than the BR Mk 1, Class 4-EPB (TOPS Class 415/1) inner suburban four-car EMU No. 5245 of the 1951 batch crosses Charing Cross Bridge on a Dartford Loop service, May 1975. Unusually, this set has two compartment second class trailers rather than the usual one.

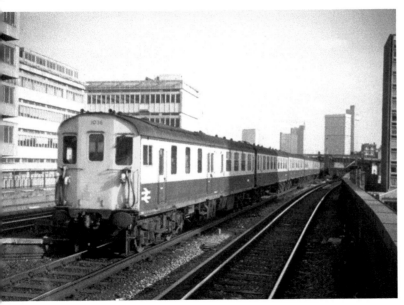

BR(SR) Class 6B (TOPS Class 203) Long-framed Hastings Buffet InterCity six-car DEMU No. 1036 on a Charing Cross–Hastings service pensively approaches Waterloo (East), July 1975.

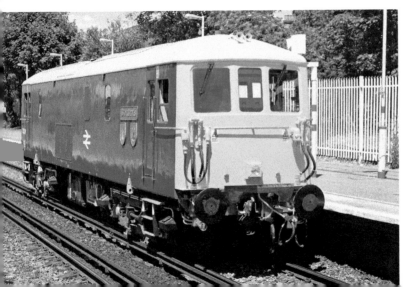

Preserved but main line registered, BR/English Electric Class 73/1 1,600 hp/600 hp electro-diesel Bo-Bo No. 73201 (ex-Nos 73142 and E6049) *Broadlands* travels light engine through Streatham Common, 23 June 2009.

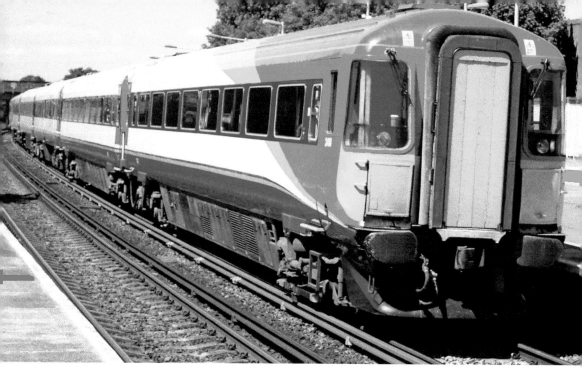

The last EMUs to be based on the Mk 3 bodyshell were the Class 442 five-car EMUs built by BREL (Derby), originally dubbed 'Wessex Express' (or 5-WES) for the extension of the Waterloo–Bournemouth electrification to Weymouth. However, on privatisation South West Trains replaced them with Desiros. After a period of storage the sets were resuscitated by Southern for the Gatwick Express service, but now they are being replaced by Class 387s. Here is No. 2418 of Southern but still in (debranded) South West Trains livery and number and yet to be refurbished. It is at Streatham Common on a Victoria–Gatwick Airport service, 23 June 2009.

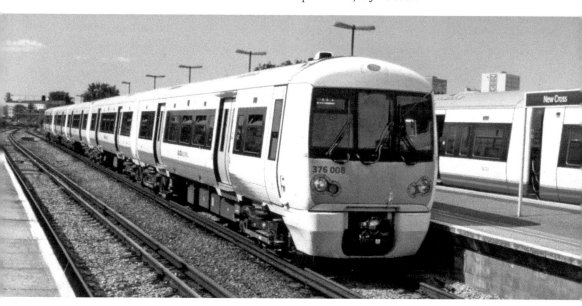

Bombardier 750 V DC third rail Class 376 Electrostar five-car EMU No. 376008 of Southeastern is at New Cross on a Charing Cross–Dartford Loop service, 6 January 2012. These were the most basic version of the Electrostar family with high-density, tram-like accommodation for short-range inner suburban services. I wonder what present-day commuters would think of the well-padded seats of the 4-SUBs and 2/4-EPBs?

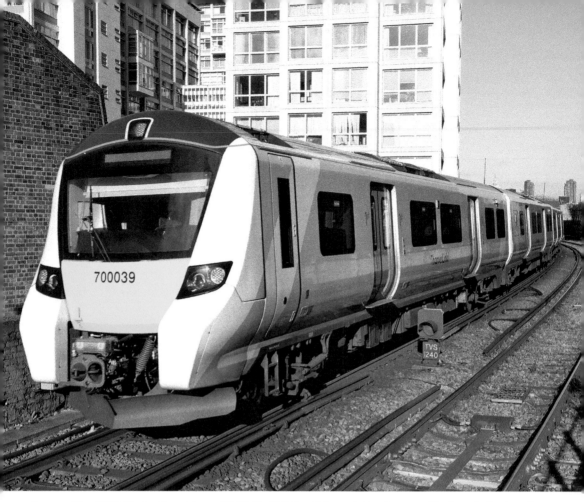

Siemens Class 700/0 Desiro City eight-car EMU No. 700039 of Thameslink is departing Elephant & Castle and heading towards Blackfriars, 25 November 2017. The Class 700s work over both the 25 kV AC overhead and 750 V DC third rail systems.

Chapter 10

Brighton Lines

The London, Brighton & South Coast Railway had major termini at London Bridge and Victoria. Both stations have been completely rebuilt in recent years, and while their efficiency has improved, their aesthetics from the platform ends have not. Particularly unfortunate is the loss of the imposing trainshed at London Bridge. Nonetheless, the interest in railway operations at both these very busy stations remains undiminished. One particularly interesting service from Victoria is the Gatwick Express, which has always had unique stock.

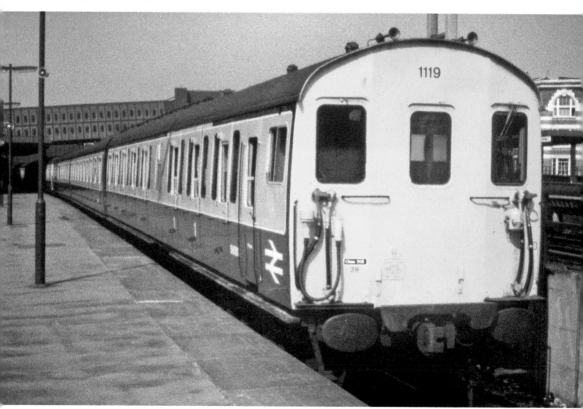

Just pulling into the Brighton side of London Bridge station on a service from Tonbridge is BR(SR) Class 3H (TOPS Class 205) Hastings three-car DEMU No. 1119 in September 1982. No. 1119 was originally built as a two-car 2H set but was later strengthened by the addition of a centre trailer.

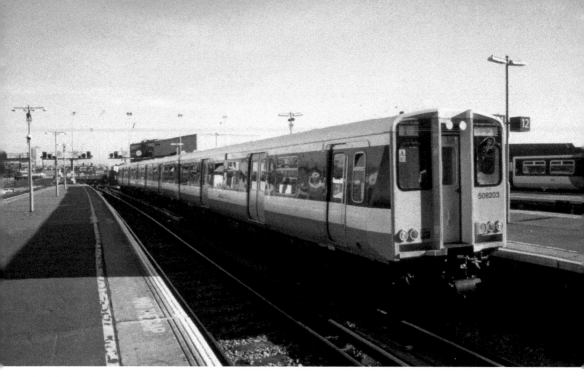

Refurbished from a Merseyrail BREL (York) Class 508/1 three-car EMU, Class 508/2 No. 508203 (ex-No. 508106) is freshly painted in Southeastern livery. This livery had actually been the new Connex South Eastern livery shortly before Connex lost their franchise and successor Southeastern simply adopted it. The unit is seen departing London Bridge in November 2008 on a Redhill and Tonbridge service, in the last days before this service was transferred from Southeastern to Southern. The unit was then returned to Merseyrail. The newly applied livery thus became inappropriate for this unit almost immediately!

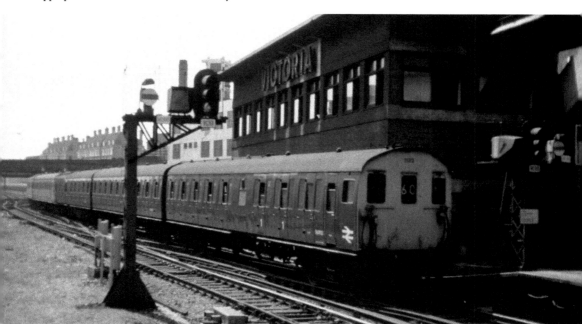

BR(SR) Class 3H (TOPS Class 205) Hampshire three-car DEMU No. 1123 (with a sister set) arriving at the Brighton side of Victoria on a service from East Grinstead via Oxted, August 1975.

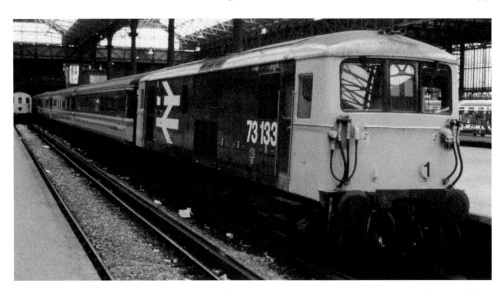

When a dedicated express service to Gatwick Airport was launched in 1984, it used air conditioned Mk 2 coaches hauled by BR/English Electric Class 73/1 (SR Class JB) 1,600 hp Bo-Bo electro-diesels or, in modern parlance, bi-mode locomotives. Awaiting departure from the Brighton side of Victoria on a Gatwick Express service in August 1984 is No. 73133 (ex-No. E6040, later named *The Bluebell Railway*) in BR Large Logo Blue livery with a rake of Class 488 Mk 2 coaches in what was then a new livery specific to the service but which was later adopted with modifications for InterCity.

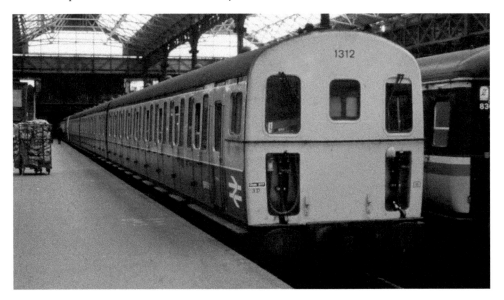

BR(SR) Class 3D (TOPS Class 207) East Sussex three-car DEMU No. 1312 is at Victoria's Brighton side on a service from Uckfield via Oxted, August 1984. Unlike all other regions that used diesel-mechanical or, occasionally, diesel-hydraulic DMUs, the SR opted for electric transmission for their units so that they would be compatible with their EMUs. In addition, the engines were housed within the body rather than under the frames. The protection from the outside elements increased the reliability of the engines, but this was at the expense of valuable passenger accommodation. Moreover, although both types of diesel unit employed the Mk 1 bodyshell, the SR sets had cabs similar to their EMUs rather than the BR (Derby) design mostly used on other regions' diesel sets.

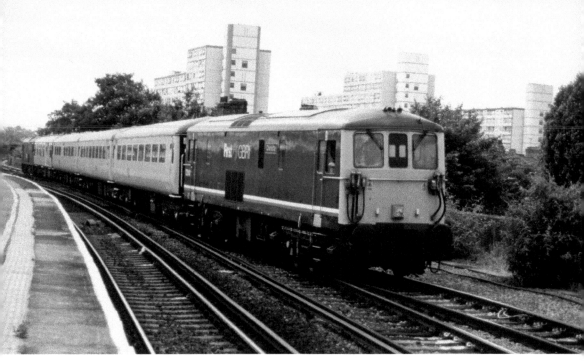

At Battersea Park in June 2010 is BR/English Electric Class 73/1 electro-diesel No. 73141 *Charlotte* of First GBRf on a Network Rail train.

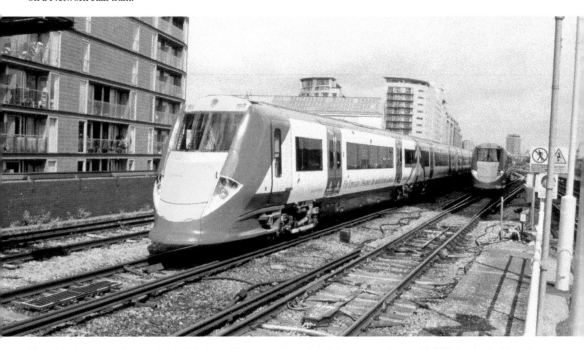

Two for the price of one – GEC-Alsthom Class 460 (or 8-GAT) Juniper eight-car EMU No. (460 0)06 of Gatwick Express in Emirates Airlines (Africa) livery speeds through Battersea Park towards Victoria, with sister set No. (460 0)05 passing in the opposite direction, June 2010. Never was a more apposite nickname applied to a train – the Darth Vaders. It is such a shame for the enthusiast that these dramatic-looking sets were broken up to strengthen the Class 458s. Although the set's full number was 460006, only the last two digits were displayed on the driving cars.

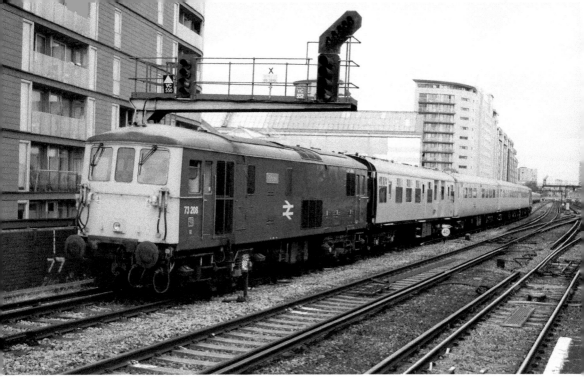

BR/English Electric Class 73/1 electro-diesel Bo-Bo No. 73208 (ex-Nos 73121 and E6028) *Kirsten* (ex-*Croydon 1883–1983*) of First GBRf in a heritage livery of BR's Rail Blue on a Network Rail train at Battersea Park, June 2010.

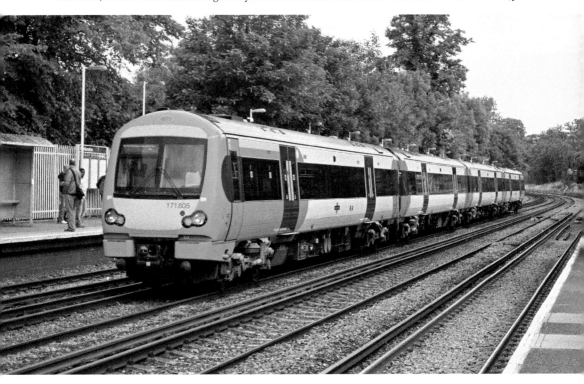

Sweeping through Sydenham on an Uckfield–London Bridge service is Bombardier Class 171/8 Turbostar outer suburban four-car DMU No. 171805 of Southern, 12 June 2009.

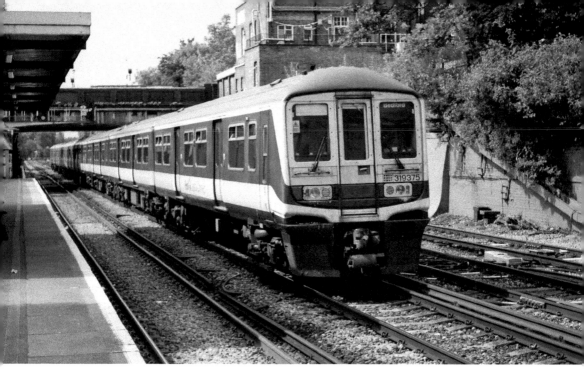

Seen speeding past Sydenham on a Brighton–Bedford service on 12 June 2009 is BREL (York) Class 319/3 (converted from a Class 319/1) four-car EMU No. 319375 (ex-No. 319175) of First Capital Connect. The set is in FCC-branded Thameslink livery. The class has dual voltage capability and can operate both under 25 kV AC overhead and on 750 V DC third rail systems.

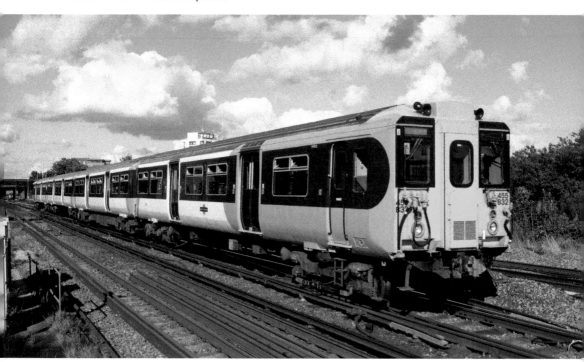

BR (York) Class 455/8 (first series) 750 V DC third rail inner suburban four-car EMU No. 455832 of Southern at Norwood Junction on 12 September 2015.

Chapter 11

South Western Lines

The London & South Western Railway's Waterloo station was first opened in 1848 and some chaotic, almost random, extensions followed over the years. Eventually, in 1909–22, the station was rebuilt and then in 1994 the Eurostar platforms were added. Waterloo was home of the famous Bournemouth Belle; this service lasted well into the diesel era as did the other loco-hauled trains to Exeter. This made Waterloo rather more rewarding from an enthusiast's point of view than the other stations south of the Thames. Aside from Eurostar, since privatisation Waterloo has been served by no more than one company, although the variety of stock used and the attractiveness of the liveries carried makes Waterloo a more interesting location than one might think.

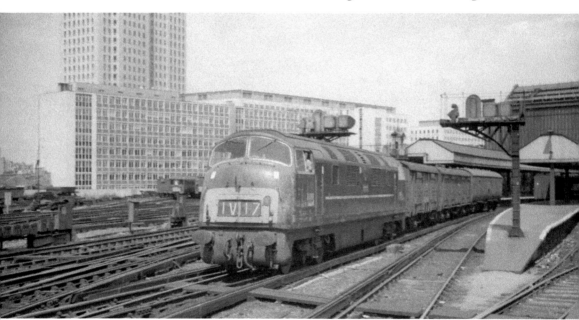

Leaving Waterloo with a parcels train in July 1967 is BR Type 4 (TOPS Class 42) or Warship Class 2,200 hp B-B No. D816 *Eclipse*. Unfortunately, the unkempt state of *Eclipse* does not do justice to its livery of Brunswick Green with a white stripe and small yellow warning panels. The Warships were based on the West German Class V200 locomotives and had an excellent power-to-weight ratio. However, the WR's attempt to go its own separate way in choosing hydraulic rather than electric transmission for its diesel classes did not succeed in the long run and eventually BR imposed the early withdrawal of the hydraulics as non-standard. But it must be said that the less than impressive reliability record of at least some of the hydraulic designs did not help their case.

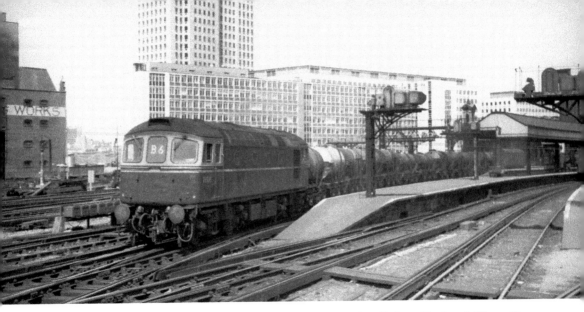

Pulling out of Waterloo on a train of milk empties in July 1967 is Birmingham Railway Carriage & Wagon Co. Type 3 (later Class 33/0) Crompton 1,550 hp Bo-Bo No. D6585 (later No. 33065) in Brunswick Green with a white stripe but, surprisingly for 1967, no yellow warning panels. In my opinion, British Railways' Brunswick Green livery set off by stripes of various light hues suited its diesels a lot better than British Rail's virtually unadorned expanse of plain blue relieved only by a vast splash of yellow on cab fronts. And the lion and wheel emblem I found much more attractive than the later double arrow symbol, innovative though the latter was.

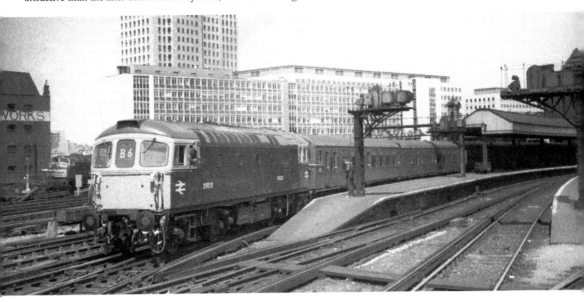

Birmingham Railway Carriage & Wagon Co. Type 3 (Class 33/1) Crompton No. D6529 (later No. 33112) eases out of Waterloo with an eleven-coach push-pull set consisting of two 4TC four-car trailer sets – Nos 417 and 413 – and 3TC three-car EMU No. 301 in July 1967. This picture illustrates my point about liveries made in the caption to the previous photograph. No. D6529 is in Rail Blue with all-yellow front ends. Despite the cleanliness of the Class 33, the impact of the plain blue seems rather dull while the large area of bright yellow is simply overdone and too great a contrast. I note with pleasure that the latest Class 68 diesels for TransPennine have no yellow warning panels at all. I have never understood why BR and its successors (until now) thought a yellow front end was vital for safety when every other railway system in the world managed quite well without them. The TC sets in the picture are also in plain blue livery but were soon repainted into the much more attractive blue and light grey livery, fortunately.

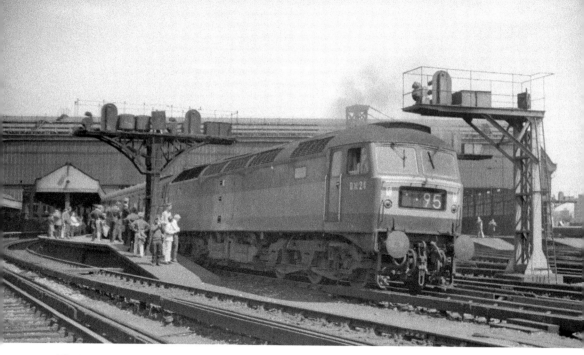

The last Bournemouth Belle Pullman to Bournemouth (West) on 9 July 1967 pulls out of Waterloo headed by Brush Type 4 (later Class 47/0) 2,750 hp Co-Co No. D1924 (later No. 47247) in BR's attractive two-tone green livery.

BREL (York) Class 508/0 inner suburban 750 V DC third rail four-car EMU No. 508033 departs Waterloo on a Shepperton service in September 1982. The Class 508s were the first second generation EMUs to enter production, developed from the Class 445 4-PEP prototypes trialled on the Southern Region. The Class 508s were intended for the Merseyside system but so urgent was the need to replace the rapidly ageing Bulleid Class 405 4-SUB stock that they were diverted to the SR instead. When eventually the Class 508s were transferred to Merseyside on the entry into service of the Class 455s on the SR, one car from each 508 set was retained by the SR for incorporation into the Class 455/7s.

On the site which became occupied by the Eurostar terminal at Waterloo, BR/English Electric Class 73/1 No. 73131 (originally numbered No. E6038, later named *County of Surrey*) awaits its next turn of duty in March 1984.

Pictured on 16 November 2017 and with the former Eurostar Waterloo terminal in the background at a lower level, Siemens 25 kV AC overhead/750 V DC third rail Class 707 Desiro City five-car suburban EMU No. 707029 waits for the off. Although now operated by South Western Railway, the set is still in the inner suburban livery of South West Trains, which ordered the Class 707s. It is ironic that the Class 707s are being delivered in SWT livery when even those delivered have had hardly any time working for the company before it lost its franchise. And it is even more ironic that the successor company doesn't even want them so they are facing an uncertain future.

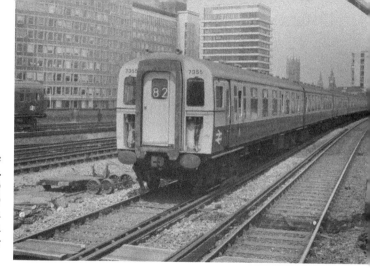

Vauxhall has long been a favourite spot for railway photographers. Approaching at speed is BR(SR) Class 4-CIG (TOPS Class 421/2) four-car EMU No. 7355 with a 4-BIG and another 4-CIG on a Waterloo–Portsmouth Harbour service, August 1975.

Another photograph from the same platform end at Vauxhall: Birmingham Railway Carriage & Wagon Co. Type 3 Crompton Class 33/0 No. 33050 (ex-No. D6568) is gaining speed in July 1975.

BR(SR) Class 4-TC (TOPS Class 491) four-car trailer MU No. 408 nears Vauxhall on a Waterloo–Bournemouth–Weymouth service in July 1975. The 4-TCs were built for use with 4-REP (Class 430) tractor EMUs, which would be detached at Bournemouth while a Class 33 would be attached to the 4-TC for onward haulage over the unelectrified track to Weymouth.

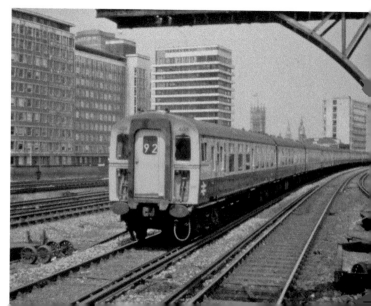

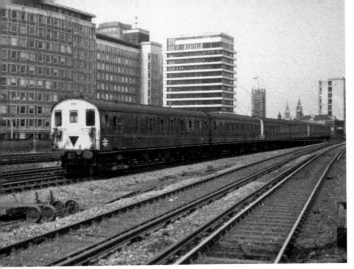

On the same day in July 1975, BR Standard Mk 1 2-EPB (Class 416/2), 1953 batch, inner suburban two-car EMU No. 5781 in Rail Blue livery (coupled to another two 2-EPB sets) approaches Vauxhall on a Waterloo–Richmond–Brentford (Central)–Waterloo circular service. The Houses of Parliament's Victoria Tower and Elizabeth Tower (with Big Ben) poke their heads up in the background which is otherwise dominated by office blocks.

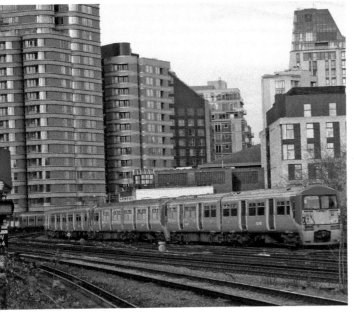

Threading its way between the modern high-rise blocks that have sprung up on the south bank of the Thames at Vauxhall since my earlier photographs is BREL (York) Class 456 inner suburban two-car EMU No. 456024 of South Western Railway (although still in South West Trains outer suburban livery). The Class 456, coupled to a sister unit and a Class 455 EMU, is Waterloo-bound on 16 November 2017.

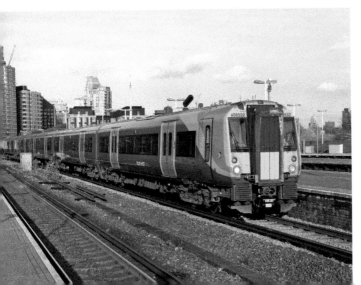

Approaching Vauxhall on a Waterloo–Windsor service is Alstom Class 458/5 Juniper or 5-JOP five-car EMU No. 458526 of South Western Railway in South West Trains outer suburban livery, 16 November 2017.

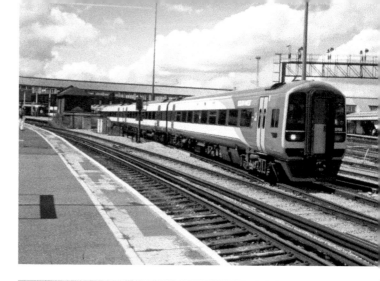

Pulling out of Clapham Junction on a Bristol Temple Meads–Waterloo via Salisbury service in July 2007 is BREL (Derby) Class 159/1 Sprinter Express three-car DMU No. 159106 (converted from No. 158809) of South West Trains in SWT Express livery.

A very colourful BREL (York) Class 455/8 (first series) four-car EMU No. (45)5856 of South West Trains in Legoland Windsor advertising livery stops at Clapham Junction on a Guildford–Waterloo service, July 2007.

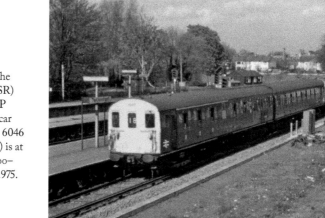

Arriving at the home of English rugby, or at least the station that serves it, BR(SR) Mk 1-bodied Class 2-HAP (TOPS Class 414/2) two-car outer suburban EMU No. 6046 (with three more 2-HAPs) is at Twickenham on a Waterloo–Weybridge service, April 1975.

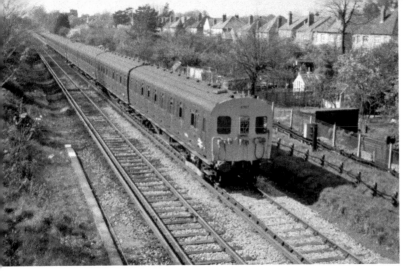

SR Bulleid-bodied Class 4-SUB (TOPS Class 405/2), 1949 batch, inner suburban four-car EMU No. 4707 is on an Alton–Waterloo service, May 1975.

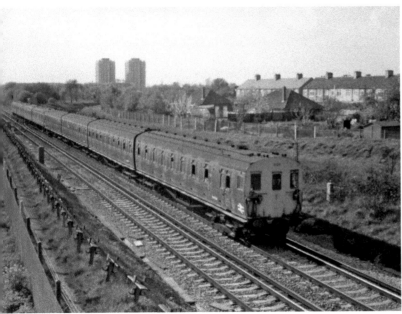

Pictured at Whitton on a Windsor & Eton–Staines–Waterloo service is SR Bulleid Class 4-EPB (TOPS Class 415/1), 1951 batch, inner suburban four-car EMUs Nos 5125 and 5134, May 1975.

Surbiton's art deco station makes a fine backdrop to Siemens Class 444 Desiro five-car EMU No. 444034 of South West Trains, which sweeps through on a Weymouth–Waterloo service, 24 March 2009.

Approaching Surbiton at speed is Siemens Class 450 Desiro four-car EMU No. 450018 of South West Trains in SWT outer suburban livery on a Waterloo–Basingstoke service, March 2009.

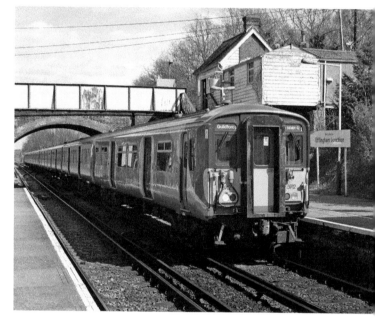

Stopping at the rather higgledy-piggledy Effingham Junction station is BREL (York) Class 455/7 (second series) four-car EMU No. (45)5912 of South West Trains in their inner suburban livery on a Waterloo–Surbiton–Guildford service, 24 March 2009.

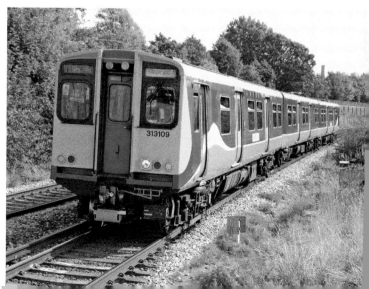

Nearing West Brompton on the West London Line is BREL (York) Class 313 inner suburban three-car EMU No. 313109 of London Overground in LO-branded Silverlink Metro livery on a Clapham Junction–Willesden Junction service, 18 September 2009. The Class 313s can work over both 25 kV AC overhead and 750 V DC third rail lines.

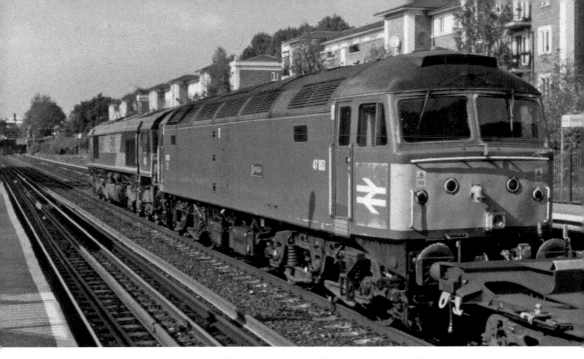

A very interesting livery is carried by Brush Class 47/4 No. D1733/47853 *Rail Express* of Riviera Trains, which had been restored in BR's experimental XP64 livery of 1964. That livery was never adopted by BR but it paved the way for the Rail Blue livery. No. D1733 is seen double-heading with DBS Class 66 No. 66161 on a freight through Kensington Olympia, 18 September 2009.

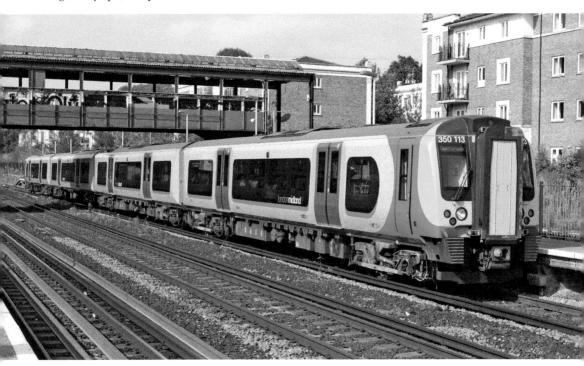

Again on the West London Line, Siemens Class 350/1 Desiro outer suburban 25 kV AC overhead/750 V DC third rail four-car EMU No. 350113 of London Midland is on hire to Southern and is pictured at Kensington Olympia station on a Milton Keynes–Clapham Junction–West Croydon service, 18 September 2009.

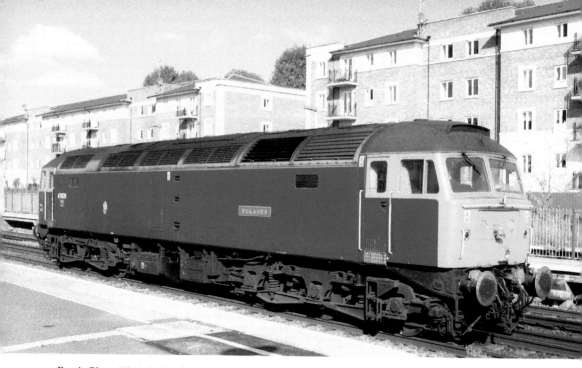

Brush Class 47/4 2,580 hp Co-Co No. 47839 *Pegasus* of Riviera Trains in their blue livery pauses at Kensington Olympia for a crew change, 12 October 2009. The locomotive was formerly numbered 47621, 47136 and D1728 and it was previously named *Pride of Saltley*, *RAF Valley* and *Royal County of Berkshire*.

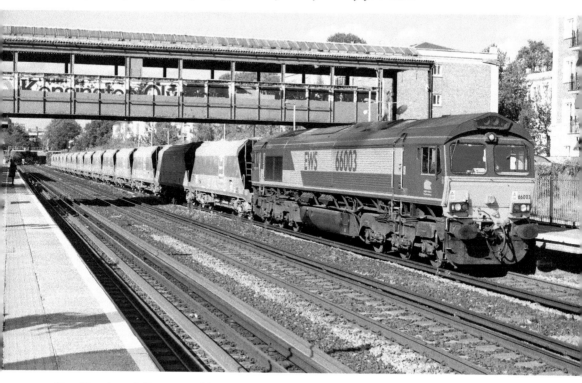

Trundling through Kensington Olympia on 12 October 2009 is GM Class 66/0 3,100 hp Co-Co No. 66003 of DBS in EWS livery on an Acton Yard–Tolworth Yeoman aggregates train of loaded hoppers.

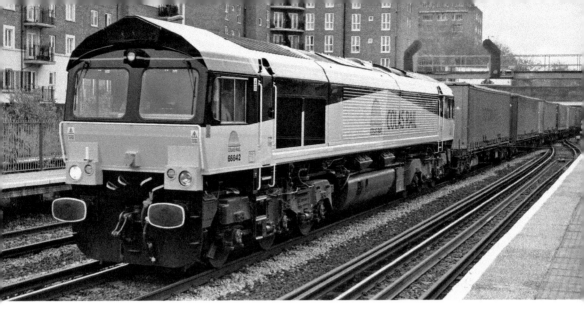

A low-emissions variant of the GM Class 66/8, Colas Rail's No. 66842 approaches Kensington Olympia on a Dollands Moor–Hams Hall 'Norfolk Line' Intermodal service, 12 November 2009. No. 66842 is newly repainted into Colas Rail's livery as Advenza Freight, which originally owned the loco, had recently gone bankrupt.

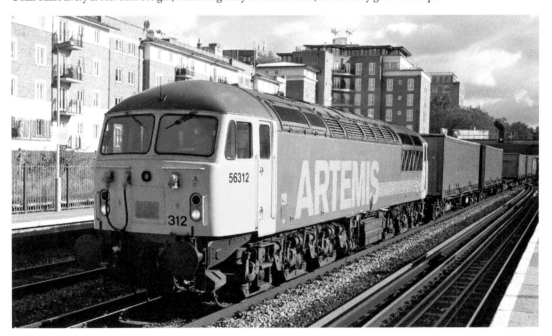

Another picture of the Dollands Moor–Hams Hall 'Norfolk Line' Intermodal service, although on this occasion it is hauled by Brush Class 56 3,250 hp Co-Co No. 56312 (ex-No. 56003) *Artemis of Hanson* in its unique purple livery, 12 October 2009. The Class 56s were arguably the last of BR's 'classic' diesels and were a hurried design to fulfil an expected large increase in coal traffic. The Class 56s employed an updated Class 47 bodyshell and a Ruston-Paxman 16RK3CT engine that was effectively a much developed and more powerful version of the English Electric 16CSVT engine used in the Class 50s. The first batch of thirty were even contracted to Electroputere of Romania to enable quick delivery. Unfortunately, the large increase in coal production never materialised; instead, a decline occurred. Coupled with the very poor construction of the Romanian locomotives, many of the Class 56s had a relatively short life, most being withdrawn in 2004. They simply could not compete with the reliability and availability of the American-built Class 66s.

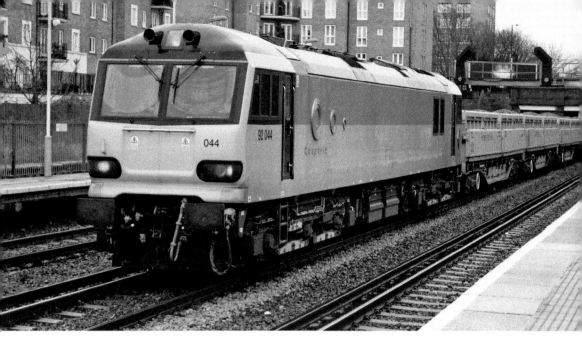

Brush Class 92 6,760 hp Co-Co No. 92044 *Couperin* of DBS in European Passenger Services two-tone grey with blue roof livery passing through Kensington Olympia on a Dollands Moor–Willesden Network Rail ballast train, 25 March 2010. Employing the same bodyshell as the diesel Class 60s, the highly sophisticated and expensive Class 90s were the last British-built main line locomotives. The Class 92s can operate both under the 25 kV AC overhead system and on the 750 V DC third rail system.

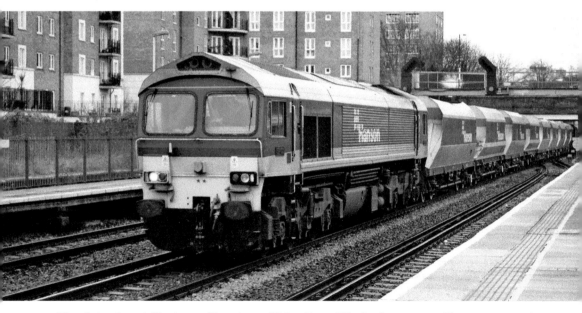

Thundering through Kensington Olympia on a Hither Green–Whatley Quarry empty Hanson aggregates hopper train is GM Class 59/1 3,300 hp Co-Co No. 59102 *Village of Chantry* (although the nameplate is missing) of the Hanson Group, 25 March 2010. The Class 59s were the first foreign diesel locomotives built for Britain and the first that were operated by a private company, not BR. Foster Yeoman were very dissatisfied by the reliability of BR's Class 56s, which operated their aggregates trains, and manged to get BR to allow them to procure and operate their own engines – and they chose an American design, the predecessor of the ubiquitous Class 66s. Other companies also chose the Class 59.

Abbreviations

AC	Alternating Current
BR	British Railways (1948–65), British Rail (1965–94/97)
BRC&W	Birmingham Railway Carriage & Wagon Co.
BREL	British Rail Engineering Ltd
DC	Direct Current
DBS	Deutsche Bahn Schenker
DMU	Diesel Multiple Unit (mechanical or hydraulic transmission)
DEMU	Diesel Electric Multiple Unit (i.e. electric transmission)
EC	East Coast
ECML	East Coast Main Line
ECS	Empty Coaching Stock
EMU	Electric Multiple Unit (AC and/or DC supply)
ER	Eastern Region of BR
ETH	Electric Train Heating
EWS	English, Welsh & Scottish Railways
FCC	First Capital Connect
FGW	First Great Western
GA	Greater Anglia
GBRf	GB Railfreight
GE	Great Eastern (lines of the ER)
GEML	Great Eastern Mail Line
GM	General Motors
GN	Great Northern (lines of the ER)
GRC&W	Gloucester Railway Carriage & Wagon Co.
GUV	General Utility Van
GWR	Great Western Railway
HST	High Speed Train
LM	London Midland (service franchisee under privatisation)
LMR	London Midland Region of BR
LMS	London, Midland & Scottish Railway
LNER	London & North Eastern Railway
LO	London Overground
LT&S	London Tilbury & Southend (lines of ER)
MU	Multiple Unit
NER	North Eastern Region of BR

NSE	Network South East sector of BR
NXEA	National Express East Anglia
NXEC	National Express East Coast
ROSCO	Rolling Stock Operating Company
SR	Southern Railway or Southern Region of BR
SWT	South West Trains
TfL	Transport for London
TOPS	Total Operations Processing System
TMD	Traction Maintenance Depot
VTEC	Virgin Trains East Coast
WCML	West Coast Main Line
WR	Western Region of BR

Bibliography

Boocock, Colin, *Railway Liveries: BR Traction 1948–95* (Shepperton, Ian Allan Publishing Ltd, 2000).

Boocock, Colin, *Railway Liveries: Privatisation 1995–2000* (Shepperton, Ian Allan Publishing Ltd, 2001).

Buchanan, Charles, *Sparks: A Celebration of British AC Electric Locomotives* (Leigh, Triangle Publishing, 2006).

Cable, David, *Lost Liveries of Privatisation in Colour* (Hersham, Ian Allan Publishing, 2009).

Cable, David, *BR Passenger Sectors in Colour* (Hersham, Ian Allan Publishing, 2012).

Clough, David N., *Diesel Pioneers* (Hersham, Ian Allan Publishing, 2005).

Jackson, Alan A., *London's Termini* (London, Pan Books Ltd, 1972).

Lewis, J. K., *The Western's Hydraulics* (Nottingham, Book Law Publications, 1977).

Lawrence, David, *British Rail Designed 1948–97* (Addlestone, Ian Allan Publishing, 2016).

Longworth, Hugh, *British Railways Electric Multiple Units to 1975* (Hersham, Ian Allan Publishing, 2015).

Mackay, Stuart, *First Generation DMUs in Colour* (Hersham, Ian Allan Publishing, 2006).

Marsden, Colin J., various parts of *Modern Locomotives Illustrated* (Stamford, Key Publishing Ltd, 2008 to date).

Marsden, Colin J., *HST Silver Jubilee* (Hersham, Ian Allan Publishing Ltd, 2001).

Marsden, Colin J., *HST The Second Millennium* (Hersham, Ian Allan Publishing Ltd, 2010).

Marsden, Colin J., *The AC Electrics* (Hersham, Ian Allan Publishing Ltd, 2007).

Marsden, Colin J., *The DC Electrics* (Hersham, Ian Allan Publishing Ltd, 2008).

Marsden, Colin J., *The Second Generation DMUs* (Hersham, Ian Allan Publishing Ltd, 2009).

Morrison, Gavin, *The Heyday of the HST* (Hersham, Ian Allan Publishing Ltd, 2007).

Oliver, Bruce, *Southern Region Electrics in Colour* (Hersham, Ian Allan Publishing, 2008).

Oliver, Bruce, *Southern EMUs before Privatisation in Colour* (Hersham, Ian Allan Publishing, 2010).

Oliver, Bruce, *Southern EMUs since Privatisation in Colour* (Hersham, Ian Allan Publishing, 2011).